Basic Techniques for
Painting
Textures
IN WATERCOLOR

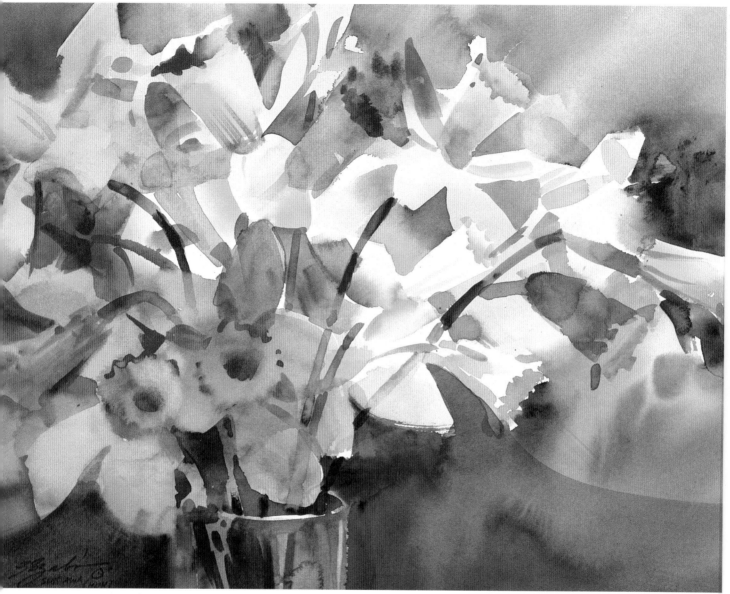

Golden Spring
14" × 18" (35.6cm × 45.7cm)
Watercolor
Zoltan Szabo

Basic Techniques for
Painting
Textures
IN WATERCOLOR

Edited by
RACHEL RUBIN WOLF

NORTH LIGHT BOOKS
CINCINNATI, OHIO

02 01 00 99 98 5 4 3 2 1

Library of Congress Cataloging-in-Publication Data

Wolf, Rachel Rubin.
 Basic techniques for painting textures in watercolor / edited by Rachel Rubin Wolf.—1st ed.
 p. cm.
 "The material in this compilation appeared in . . . previously published North Light Books"—T.p. verso.
 Includes index.
 ISBN 0-89134-853-0 (pbk.: alk. paper)
 1. Watercolor painting—Technique. 2. Texture (Art) I. Wolf, Rachel
ND2365.B37 1998
751.42′2—dc21
 97-37173
 CIP

Edited by Rachel Rubin Wolf
Content edited by Karen A. Spector
Production edited by Marilyn Daiker
Cover designed by Kathleen DeZarn
Cover illustration by Claudia Nice

The material in this compilation appeared in the following previously published North Light Books and appears here by permission of the authors. The initial page numbers given refer to pages in the original work; page numbers in parentheses refer to pages in this book.

Johnson, Cathy. *Painting Watercolors*, © 1995. Pages 6-15, 22-29, 48-49, 52-53, 76-77, 74-75 (pages 10-19, 24-31, 72-73, 80-81, 88-89, 122-123).

Katchen, Carole. *Make Your Watercolors Look Professional*, © 1995. Pages 121, 108-111, 38-39, 34-37 (pages 5, 50-53, 66-67, 84-87).

Nice, Claudia. *Creating Textures in Pen & Ink With Watercolor*, © 1995. Pages 14-21, 122-123, 124-125, 118-119 (pages 32-39, 108-109, 120-121, 124-125).

Reynolds, Robert, with Patrick Seslar. *Painting Nature's Peaceful Places*, © 1993. Pages 20-23, 83, 78-81 (pages 20-23, 44, 68-71).

Richards, David P. *How to Discover Your Personal Painting Style*, © 1995. Pages 118, 96-99 (pages 6, 46-49).

Rocco, Michael P. *Painting Realistic Watercolor Textures*, © 1996. Pages 36-39, 42-43, 48-49, 40-41, 34-35, 62-63, 66-67, 64-65, 68-69, 74-77, 114-115 (pages 90-93, 94-95, 96-97, 98-99, 100-101, 104-105, 106-107, 110-111, 112-113, 114-117, 118-119).

Szabo, Zoltan. *Zoltan Szabo's 70 Favorite Watercolor Techniques*, © 1995. Pages 133, 92-97, 60-61, 76-77 (pages 2, 74-79, 82-83, 102-103).

Wagner, Judi, and Tony van Hasselt. *Painting With the White of Your Paper*, © 1994. Pages viii-1, 124-125 (pages 89, 40-41).

Wiegardt, Eric. *Watercolor Free & Easy*, © 1996. Pages 104-105, 106, 22-29, 33-33, 30-31 (pages 42-43, 45, 54-61, 62-63, 64-65).

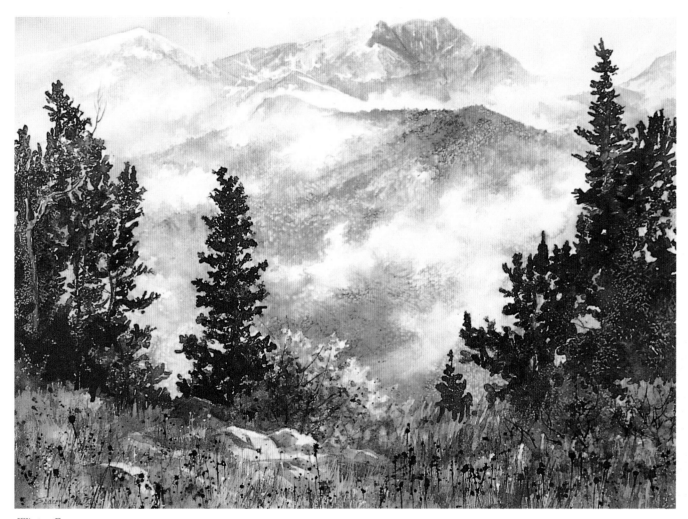

Winter Fog
21" × 28" (53.3cm × 71.1cm)
Watercolor
Sharon Hults

ACKNOWLEDGMENTS

This book would not have been possible without the special artists and authors whose work appears herein:

Mary DeLoyht-Arendt	David P. Richards
Charlene Engel	Michael Rocco
Sharon Hults	Edith M. Roeder
Cathy Johnson	Patrick Seslar
Carol Katchen	Carol Surface
Michael Kessler	Zoltan Szabo
Jim McVicker	Tony van Hasselt
Carl Vosburgh Miller	Judi Wagner
Claudia Nice	Frank Webb
Robert Reynolds	Eric Wiegardt

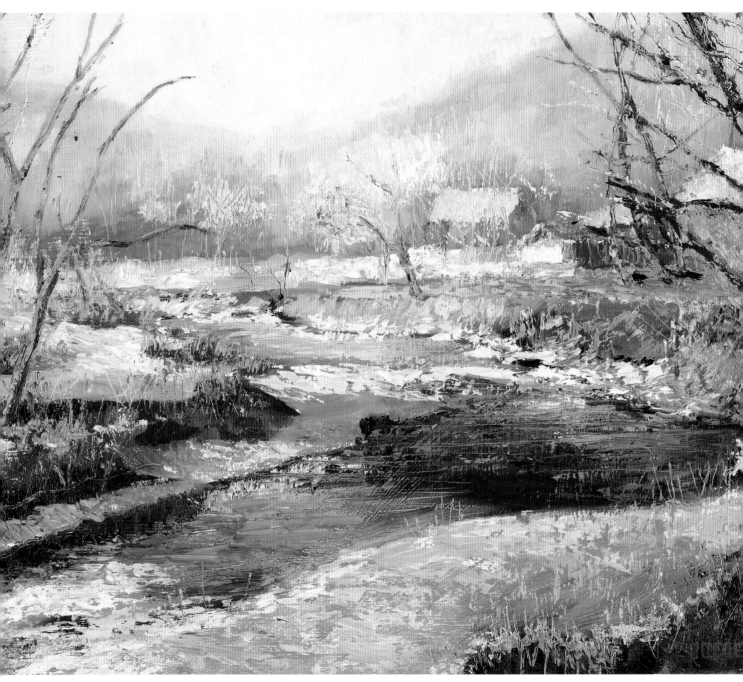

Thaw on Lizard Creek
16" × 20" (40.6cm × 50.8cm)
Oil
Edith M. Roeder

TABLE
of
CONTENTS

CHAPTER ONE

BASIC MATERIALS
AND TOOLS

PAGE 10

CHAPTER TWO

MAKING MARKS WITH
YOUR BRUSHES AND TOOLS

PAGE 20

CHAPTER THREE

TECHNIQUES FOR A
VARIETY OF SURFACE
TEXTURES

PAGE 32

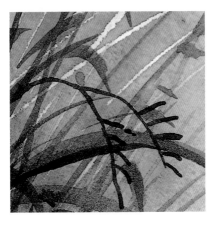

CHAPTER FOUR

TEXTURE IN EDGES
AND LINES

PAGE 54

CHAPTER FIVE

TEXTURES FOR
NATURE SUBJECTS

PAGE 66

CHAPTER SIX

TEXTURE TECHNIQUES
FOR NINETEEN
OTHER SUBJECTS

PAGE 88

INTRODUCTION

Texture is one of the more subtle elements of design. It is expressive and emotional, and in many ways, it is the telltale fingerprint of an artist. Compare, for example, the bold textures of an Edward Hopper painting with the finely textured dry-brush paintings of Andrew Wyeth. Texture, or the lack thereof, can set the stage for an agitated mood or a quiet one.

We all work with a fairly similar and basic set of art-making tools: paper, pigments, brushes and other useful items. What distinguishes one artist's work from another, however, is not our tools but how creatively we learn to use them. This book will give you dozens of ideas and techniques to jump-start your creativity.

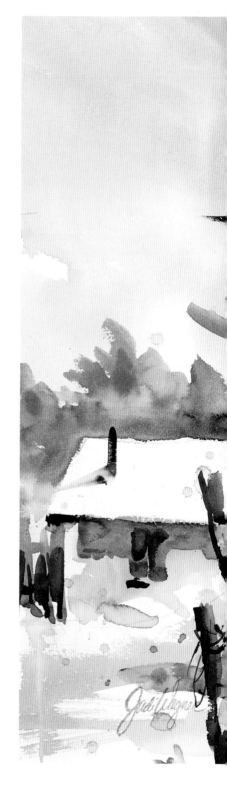

The Shackford Place
22" × 30" (55.9cm × 76.2cm)
Watercolor
Judi Wagner

Basic Materials and Tools

There is a wonderful array of tools and gadgets designed to make it easier for you to paint in watercolor, though the equipment you need to get started is relatively simple.

The *most* basic supplies for watercolor are paints, paper, brushes, a water container and a palette. The ones you choose can make the difference between enjoying your work or not. Here is a basic supply list—these are generally considered typical watercolor necessities. Some of these you will use, some you won't. You may discover other supplies along the way as well.

- Paper
- Paints
- Brushes
- Painting support
- Palette
- Water container
- No. 2 pencil
- Soft eraser
- Masking or drafting tape
- Paper towels, tissues or rags
- Liquid mask (frisket)
- Rubber cement pickup

If you find that you prefer to paint big, splashy paintings, a teeny, tiny field box with a few half pans and a no. 4 brush will drive you crazy. If, on the other hand, you have limited space, you like to keep things manageable, and you are most comfortable working on a smaller scale, you will not need the huge inch-wide brushes and full-sized paper supports. Look over our list of basics and choose what is best for you.

Paper

It isn't necessary to paint full-sheet size [approximately 22″ × 30″ (55.9cm × 76.2cm)]. And besides, face it—you *are*

Cut in half

Or any size you like

Or eighths

Or quarters

going to waste some paper. Nobody gets through the learning stage without throwing away a lot of false starts; these are called "practice runs."

Consider cutting the big, full sheets in half or in quarters, or buy a watercolor pad or block of the size you want while you learn your way around.

If price is a consideration, working smaller lets you get by with smaller, less expensive brushes, smaller palettes and smaller amounts of paint.

You can buy paper in a spiral-bound pad, a hardbound sketchbook or a block. Blocks come in sizes from 4″ × 6″ (10.2cm × 15.2cm) to 18″ × 24″ (45.7cm × 61cm) and larger. Blocks allow for plenty of versatility, though you may find that the larger-sized blocks buckle more than you like before drying flat again.

Three types of watercolor paper are

available: rough, cold-press and hot-press, which refer to surface texture. This texture is created during the manufacturing process, and it is determined by the coarseness of the metal screen the paper is dried on as well as *how* it is dried. (Is it air dried as is? Weighted down? Pressed with heat added?)

TIP

You'll find 140-lb. (330g/m²) cold-press paper meets most needs, is easiest to handle and is often less expensive than the heavier paper or more exotic surfaces—you can't go wrong!

Rough Paper

Many watercolorists prefer *rough paper*. In practice, the rough paper's surface makes texturing relatively simple; you can run an almost-dry brush over the surface of the little hills, just touching their peaks, to suggest any number of effects. (Those effects, however, will be dictated by the texture of the paper itself.)

Oddly enough, it is easier to do a smooth wash on most rough papers than on any other option you may choose. The color tends to average itself out in all those little valleys.

Cold-Press Paper

Versatile *cold-press paper* is somewhere between rough and smooth. Unlike rough, it has been weighted down in the drying process, but without heat added—literally, cold-pressed. Its surface is just pleasantly textured offering the best of both worlds.

With cold-press paper, you can create your own textures or take advantage of the subtle texture of the paper itself for dry-brush effects. You can put down a nice graded wash with very little trouble.

Hot-Press Paper

Hot-press paper is very smooth because it has been pressed with a hot iron. With this surface, you create your *own* textures, since the paper has virtually none of its own. It also makes nice *puddles*, or hard-edged shapes, where pools of pigment have dried. These can be very exciting if you are expecting them and plan for them. If you prefer a smoothly blended, wet-into-wet, "misty" effect or more control, use cold-press paper.

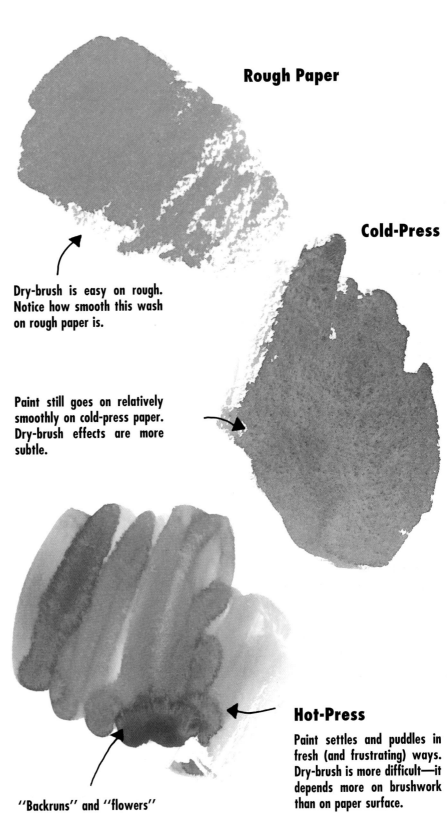

Rough Paper

Cold-Press

Dry-brush is easy on rough. Notice how smooth this wash on rough paper is.

Paint still goes on relatively smoothly on cold-press paper. Dry-brush effects are more subtle.

Hot-Press

Paint settles and puddles in fresh (and frustrating) ways. Dry-brush is more difficult—it depends more on brushwork than on paper surface.

"Backruns" and "flowers"

Look at rough or cold-press paper in strong diagonal light. You can see shadows that may "gray" your painting slightly. . .

. . . sort of like how the world appears through dark glasses. Watercolor needs light! You can compensate for the shadow effect with good, clear color.

Paper Weights

Watercolor paper comes in various weights, from 70 lb. (150g/m²) to 140 lb. (300g/m²) to 300 lb. (640g/m²) and more. This refers to the weight of 144 sheets, not to a single sheet. A sheet of 300-lb. (640g/m²) paper is much thicker than the same-sized sheet of 70-lb. (150g/m²). The heavy-weight paper doesn't need stretching or taping down when painting to keep it from buckling, no matter how wet you paint.

The 140-lb. (300g/m²) paper has a nice medium weight and generally doesn't need stretching either. The ripples that may occur in this paper during painting will generally disappear when it dries. The 70-lb. (150g/m²) paper, on the other hand, buckles badly when wet. It is the least expensive, though, so if you prefer, try it out on very *small* paintings or stretch it before painting for best results. (We will get to the how-to of stretching a bit further on.)

The designations for the "heavier" weights [555-lb. (640g/m²), 1,114-lb. (640g/m²)] that you may see refer generally to the fact that those types of papers are larger than 22″×30″ (55.9cm× 76.2cm), not *thicker* than the 300-lb. (640g/m²) designation. Generally speaking, the heavier the paper, the more expensive it is.

Test each of these papers with some of the basic techniques to see which you prefer. You may find that you choose one paper for a specific mood or effect and another for a different purpose.

Paper Sizing

Sizing affects how your chosen paper takes washes and handles abuse. Without sizing, it would be as absorbent as a paper towel. Smooth washes or crisp edges would be impossible. Sizing also adds strength, allowing you to "get rough" for certain effects without ripping through the paper. On a paper with *lots* of sizing, like Arches, you can scrape, sponge and even sand the surface.

TIP

You might want to buy a paper sampler and explore your options even if you are *not* a beginner. (We all need to take a fresh look at what we are doing and what is available on the market now and again.)

Try out rough and cold-press, heavy and light papers. Experiment with the superabsorbent Oriental papers if you like, just to see how they act. Look at this as *play*—as exploring new territory. You don't have to master them all. Just find the one you like best.

Stretching Paper

It usually isn't necessary to stretch your paper, even if you're using 140-lb. (300g/m²). (Although we recommend stretching the 70-lb. (150g/m²) papers.) Instead, just tape your paper to your board with 1½-inch (3.8cm) masking or drafting tape. What small rippling does occur in the painting process dries flat.

If you *do* want to stretch—and we'll admit, the taut surface that resists buckling even under the wettest washes is nice—here is how to go about it:

Step One

Get a sheet of plywood or Masonite (marine finish but not oil-coated) a few inches larger than the size of your paper. Wet down your paper well on both sides. (Spray it with the dish sprayer on the sink, take it into the shower, or soak it in the tub until it's really wet.)

Step Two

Lay your paper on your painting surface. Using wide [at least 1½-inch (3.8cm)] gummed tape—the type that must be moistened—fasten it down well on all four edges. Make sure that at least half the width of the tape is on the paper.

Step Three

Some artists staple the edge of the paper to the board at close intervals before taping, to ensure success—easier to do on plywood than on fiberboard. You can also buy a stretching board.

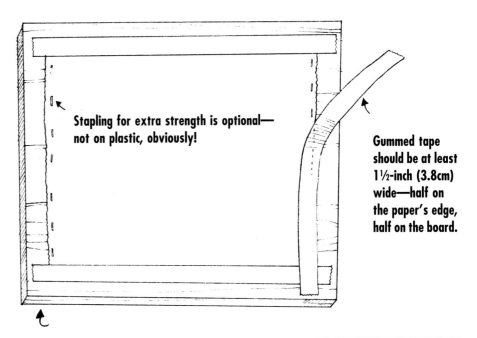

Stapling for extra strength is optional—not on plastic, obviously!

Gummed tape should be at least 1½-inch (3.8cm) wide—half on the paper's edge, half on the board.

Use a good, thick board (plywood, hardboard, heavy plastic)—at least ¼-inch (6mm) thick. Wet paper shrinks as it dries, and it can actually bend (or break!) a too-light board.

Step Four

Let it dry naturally. Don't try to hurry it along with a hair dryer or other artificial heat source, which can produce an uneven pull. If possible, let it dry flat, rather than propping the support up against the wall. Gravity pulls the moisture to the bottom, hence the top dries first.

TIP

The tape provides a clean, white edge. If you want, you can remove it in the middle of a painting—the edge acts as a trial mat and allows you to evaluate your progress. Replace the tape if you feel you're not finished. Make sure your painting is completely dry before removing the tape, though. When the paper is damp, it is likely to tear.

TIP

If you find that you really prefer a firm, wrinkle-free surface but don't like to stretch paper, you can buy watercolor board; Strathmore's Crescent Board is very good. It *is* expensive, but you can cut the large sheets to any size you like. Since it has been bonded to a cardboard backing, the rough surface is a bit smoother than unbonded paper.

Basic Brushes

Once upon a time, watercolorists bought several sizes of round red sable brushes and let it go at that. Now we cannot get by without a choice of flats, rounds, chisels, fans and bristle brushes.

Quality is important, but there are degrees of quality and reasons for choosing different brushes.

Kolinsky is the best brush hair available. The brushes are made from the tails of rare Siberian martens. Kolinsky makes a wonderful point and holds a lot of water; it's simply the best. Red sable is made from the tail of the Asiatic weasel and is slightly less expensive; it, too, is a pleasure to use.

Camel-hair brushes, oddly enough, may not contain any more of a camel than its name. Camel-hair is a trade name for brushes containing squirrel, pony, bear or goat hair (or any combination thereof). A brush with man-made fibers mixed with natural animal hair is a less expensive but viable option.

Some perfectly usable brushes are *completely* man-made and are much less expensive than Kolinsky or red sable. They may not hold quite as much liquid as the natural-hair brushes, but they have a nice snap, and they hold a point well.

Round watercolor brushes come in sizes from 000 to 24. A no. 2, a no. 8 and a no. 12 are usually sufficient. If they maintain a good point, the fives are plenty small enough for details. Sable rounds are prized for their ability to point well and still deliver a load of pigment; the use of sable for other brush types is far less critical. A mixture of natural hair and man-made fibers or a completely manufactured "hair" may be just fine for other brushes.

Flat brushes—sable or otherwise—are often sold by width: ½-inch (13mm), 1-inch (25mm), etc. They may also be sold by a size number. Try to have a ½-inch (13mm), a ¾-inch (19mm), and a 1-inch (25mm) on hand. Flats may have longer or shorter hairs proportionately to their width. The shorter brushes are easier to handle but do not hold as much water. The longer brushes may spring back when you lift them off the page thus spattering your work with droplets of color. Look for a brush that is not much longer than it is wide. Many flat brushes come with an angled end on the plastic handle that is excellent for scraping and lifting.

Good brands are Winsor & Newton, Grumbacher, Raphael, Robert Simmons, Masterstroke, Loew-Cornell, Daniel Smith, Isabey, Liquitex, Artsign, White Sable and Golden Taklon. Loew-Cornell's La Corneille is a good man-made brush that keeps its point for a long time and costs very little.

TIP

Test before you buy, if possible; most good art supply stores offer containers of clear water. Rinse the brush to rid it of sizing (yes, brushes are sized, too, for protection during shipping), make a snapping motion with your wrist to flip the excess water out, and look to see if the brush has maintained a good point; if it has, buy it.

No. 2

No. 8

No. 12

Round Brushes

Beyond Basic Brushes

Beginners often try to get by with tiny little brushes—don't. It just makes it harder to learn to handle the medium. Tiny, tiny brushes don't hold enough liquid and encourage overly tight handling. If price is a factor, try the man-made brushes, but get at least a no. 8 or no. 10 round and a ½-inch (13mm) and a 1-inch (25mm) flat. You will want to choose the largest brush you can comfortably work with to paint. It will hold more water and pigment and cover more ground before needing refilling with fresh paint.

Take care of your brushes. Don't stand them on their tips in water or they will set up that way. Do not soak them overnight, either; that can soften the glue that holds the hairs in place. A canvas or reed brush holder will protect their tips during travel. At home, you may want to store brushes upright in a jar on their handles or in a drawer with a few mothballs if you do not paint for long periods. (Moths like fine watercolor brushes as much as woolens.)

TIP

A general rule of thumb is to use the big brushes as long as you can to paint broad areas like backgrounds and such. As you paint the smaller shapes in the middle ground and foreground, you can switch to a medium-sized brush. Save your smallest brushes for fine details at the very end of a painting.

¾-inch (19mm)

½-inch (13mm)

1-inch (25mm)

Specialized Brushes

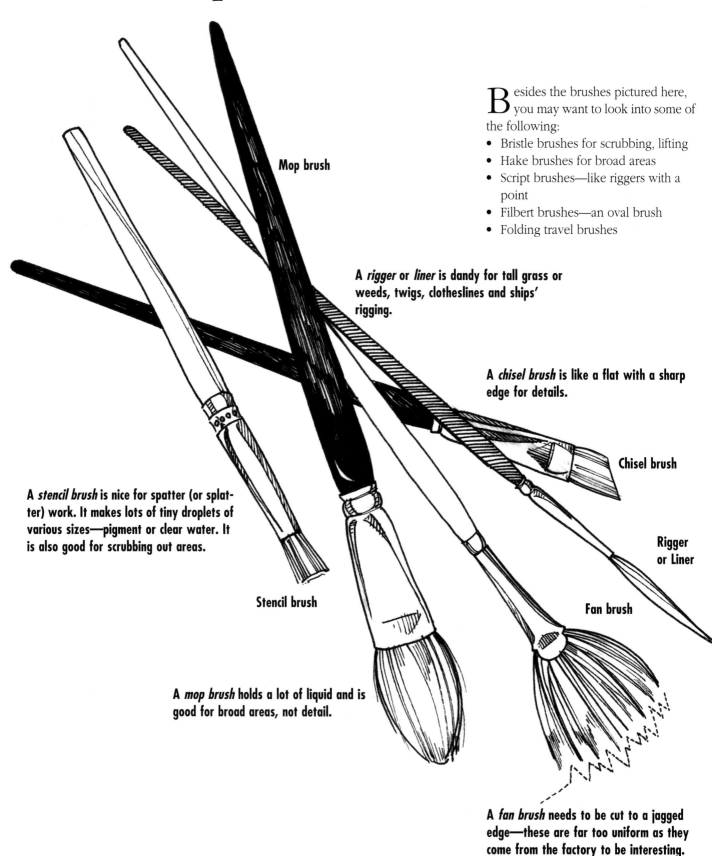

Besides the brushes pictured here, you may want to look into some of the following:
- Bristle brushes for scrubbing, lifting
- Hake brushes for broad areas
- Script brushes—like riggers with a point
- Filbert brushes—an oval brush
- Folding travel brushes

Mop brush

A *rigger* or *liner* is dandy for tall grass or weeds, twigs, clotheslines and ships' rigging.

A *chisel brush* is like a flat with a sharp edge for details.

Chisel brush

A *stencil brush* is nice for spatter (or splatter) work. It makes lots of tiny droplets of various sizes—pigment or clear water. It is also good for scrubbing out areas.

Rigger or Liner

Stencil brush

Fan brush

A *mop brush* holds a lot of liquid and is good for broad areas, not detail.

A *fan brush* needs to be cut to a jagged edge—these are far too uniform as they come from the factory to be interesting.

Paints

For ease of handling and permanence, choose *artist's grade* rather than student grade. Choose a limited palette of only a few colors and go with the best. If you want to try a limited palette, buy a warm and a cool shade of red, yellow and blue, then add a couple of earth colors.

- Alizarin Crimson (cool)
- Cadmium Red Medium (warm)
- Phthalo or Antwerp Blue (cool)
- Ultramarine (warm)
- Cadmium Yellow Lemon (cool)
- Cadmium Yellow Medium (warm)

Also get Burnt and Raw Umber and Burnt and Raw Sienna. With just these colors, you can mix all your secondary greens, purples and oranges, just like we learned in school.

You can supplement this list with a Hooker's Green Dark and a Winsor Green for fast mixing. Try using Permanent Rose when doing spring flowers or if you need a clean, clear lavender.

An even more limited palette could contain a *single* red, blue and yellow, plus an earth color or two. You sacrifice some purity in the secondaries, but it's a good place to start if price is a serious consideration.

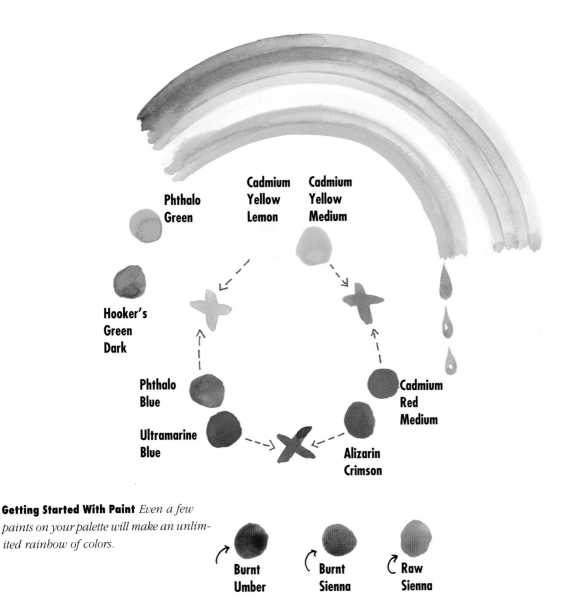

Phthalo Green

Cadmium Yellow Lemon

Cadmium Yellow Medium

Hooker's Green Dark

Phthalo Blue

Ultramarine Blue

Cadmium Red Medium

Alizarin Crimson

Getting Started With Paint *Even a few paints on your palette will make an unlimited rainbow of colors.*

Burnt Umber

Burnt Sienna

Raw Sienna

The Artist's Palette

Here, we are not discussing the pigments you choose but the surface you mix them on—also called a *palette*. Your palette should have an edge of at least ¼-inch (0.6cm) to keep washes from spilling, and it should be white, to allow you to judge the color and strength of your paint mixtures. A butcher's enamel tray is relatively inexpensive. A high-impact plastic or plastic-and-rubber mix is fine, too, and available almost anywhere art supplies are sold. A white porcelain dinner plate or platter works well, but a palette with dividers around the edge for mounds of paint keeps colors from running together.

You can try a John Pike palette, which has a lid to protect paints from dust (and other contaminants). The lid acts as an additional mixing space for big washes. The San Francisco Slant palette is nice for the variety of mixing wells to keep your washes pure and separate, or you may find that you prefer a smaller, round palette arranged like a color wheel to organize your paints for quick mixing.

Expense

How much you spend depends on what you have decided is basic. You can get started for about twenty-five to fifty dollars if you are careful. A quick look at one of the catalogs (not a discount one, either) turned up a good-sized plastic palette for about twelve dollars; a basic set of twelve small tubes of color for just over seven dollars; two man-made brushes (a 1-inch (25mm) flat and a no. 8 round) for about fifteen dollars; and a 10″×14″ (25.4cm×35.6cm) block of fifteen sheets of watercolor paper for

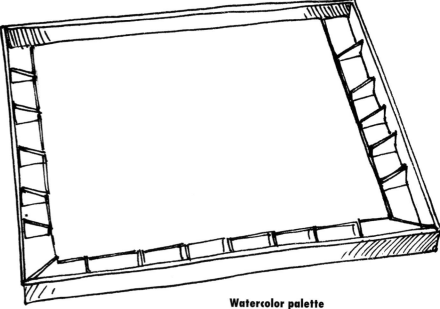

Watercolor palette

about twelve dollars [a 15″×20″ (38.1cm×50.8cm) block was about twenty]. Ten sheets of 22″×30″ (55.9cm×76.2cm) rough watercolor paper, 140-lb. (300g/m²), cost just over three dollars a sheet, not such a bad investment in yourself—especially if you cut them to size to make them go farther.

Some Further "Necessities"

• Unless you're using a watercolor block or a good, thick pad, you will need a *painting surface* to support your paper. Quarter-inch (6mm) marine plywood is good. Hardboard is another fine choice; be careful to avoid the oil-finished product. At your art supply store, you can get hardboard painting supports with a handle cut out and big metal clips at one end to hold several sheets of paper. Plexiglas, which has a nonporous surface, helps hold the moisture in the paper longer.

TIP

Pull tape off at an acute angle to your paper to minimize damage or tearing.

TIP

If you use a brush to apply your mask, dampen it with soapy water first so you can easily wash out the rubbery liquid when you're done.

Basic Techniques for Painting Textures in Watercolor

Keep two containers of water handy, one within the other—try a large margarine tub with a jar in it. You can rinse your brush in one and use the other for mixing unsullied washes.

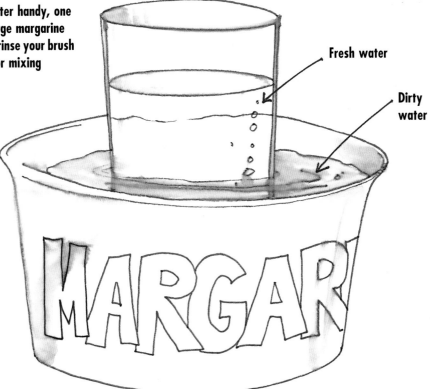

Fresh water

Dirty water

• *Drafting* or *masking tape* is fine to attach paper to the board (remove it carefully when the painting is bone dry) or use *staples* or *bulldog clips*, which can be moved during painting, if you like.

• *Liquid masking compounds* are helpful for protecting areas of the paper you want to remain white when you splash on preliminary washes; Maskoid, Miskit, Liquid Frisket and Incredible White Mask are some familiar brand names.

• You will need a *pencil* and an *eraser*, not too many people paint directly with no guidelines. A no. 2 or HB pencil is basic, but choose the finest, gentlest eraser you can find. A White Magic works well, as does Pentel's Clic Eraser. Neither will damage the surface of your watercolor paper.

• Your *water container* should be unbreakable. For travel, try an old army canteen with a cup.

• Use *sponges* to wet paper with clear water, to remove excess sizing, to mop up, to lift color or to paint with. Pick up a selection of natural and man-made ones.

• Keep *paper towels* or *tissues* handy. A paper towel in one hand and a brush in the other allows you to quickly change the texture of a wash, lighten an area, or pick up a bobble or spill so it doesn't even show—if you're prepared.

• A *portable hair dryer* set on warm will speed drying, but keep it moving at a distance of perhaps 18-inches (45.7cm) from your paper or you may make hard edges.

• That *spray bottle* can be quite handy

for more than moistening dried paint. If an area of your painting has gotten too busy, spray it and flood in a unifying wash. Soften edges of a wash with a shot of spray, too.

TIP

Keep a sponge right on your palette (or close by) to absorb extra moisture in your brush, to modify or lighten a wash or to pick up spills.

Making Marks With Your Brushes and Tools

Artists use a variety of expensive and inexpensive brushes, ranging from high-quality sables costing several hundred dollars each to inexpensive synthetics costing only a few dollars each. When selecting brushes, weigh performance and durability against cost. Texture techniques can be rather rough on brushes if you use them for scumbling or similar rough uses. Even so, some artists lean toward the more expensive, high-quality sables because of their superior performance. Synthetic brushes are a quite acceptable alternative; they don't hold as much paint as natural sables do, but they will definitely do the job.

Brushes like these are used to create textures.

Rounds, in nos. 2, 4, 6, 8, 10, 12

No. 6 bamboo

1-inch (25mm) flat

2-inch (51mm) hake

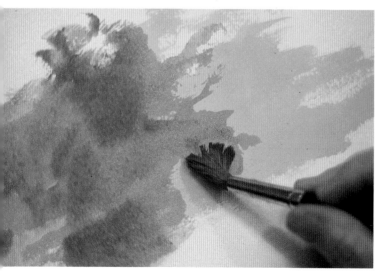

Scumbling *Traditionally linked to oil painters,* scumbling *means working a layer of semiopaque color over an existing color so that the first color is only partially obscured by the second. This produces a broken color effect. For watercolorists, scumbling produces an effect somewhere between semiopaqueness and transparent "glazing," and consequently it's very important that the second layer of color doesn't become so opaque that the transparent quality of the painting is lost.*

Round Brushes

The hairs of a good quality round brush should form a bulletlike shape that tapers evenly to a pointed end. Even after considerable use, it should return to its original shape and retain its pointed tip. It should be capable of painting a thick or thin line and should move between those extremes with ease.

Again, the best round brushes are pure sable, and individual prices vary considerably according to the quality and availability of sable hair, but you won't be sorry if you can manage to set aside several hundred dollars to buy a few top quality sable brushes. If this is out of your price range, the synthetics are quite good, and the relatively inexpensive Liquitex Kolinsky Plus series of brushes perform well and are fairly durable.

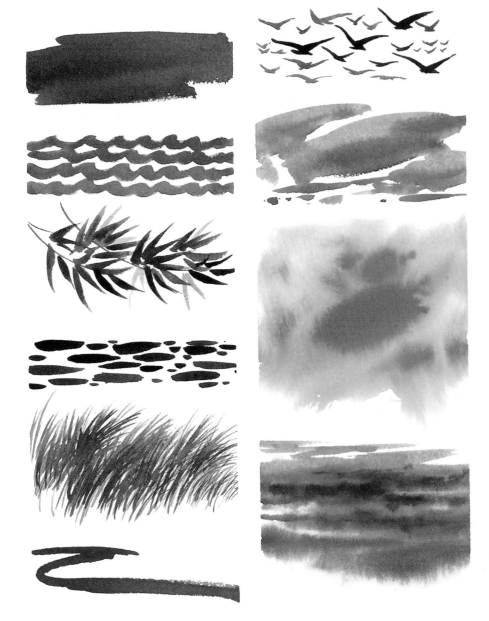

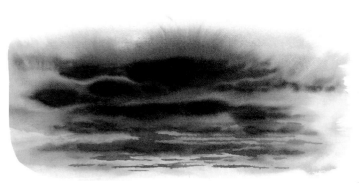

A sky study was created using round brushes in a wet-into-wet technique.

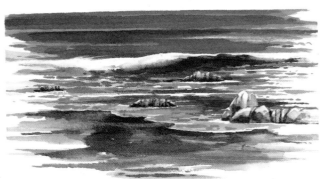

An ocean study was created using round brushes to apply various layers and values of blue in a calligraphic manner.

Flat Brushes and Hake Brushes

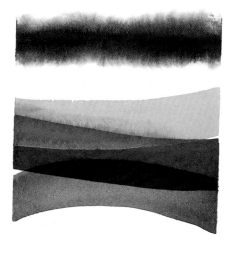

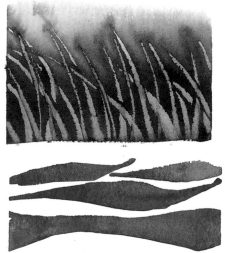

Sample Textures Created With a 1-Inch
(25mm) Flat Brush

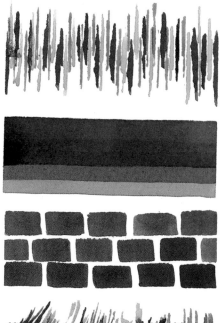

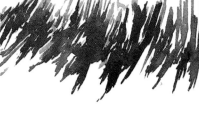

Flat Brushes

A top-quality flat brush retains its shape after repeated use and forms a sharp, flat end. The hairs shouldn't separate when applying a graded wash or where absolute control is essential. However, a good flat brush should be able to be splayed to achieve various textural effects and still return to its original shape.

There are extensive uses for flat brushes, so always keep a number of them on hand. Be careful not to allow the effects produced by any one type of brush to dominate your paintings. Otherwise, the results can appear quite choppy.

Hake Brushes

Oriental hake brushes ranging in width from 2-inches (51mm) to 3½-inches (89mm) are especially effective for large, watery skies or expansive fields of grass (see the sample hake brushstrokes at right). One caution: Be careful that the wooden part of the brush doesn't come in contact with your paper. Hake brushes have rather short bristles, and the wooden shank can easily scratch or bruise the surface of your paper. It can be singularly disheartening to accomplish a beautiful sky only to discover a long, unattractive bruise amidst your "strokes of genius."

Hake Brush Textures

Basic Techniques for Painting Textures in Watercolor

Oriental Bamboo Brushes

Thanks to its long hairs and somewhat coarse inconsistencies, the Oriental bamboo round brush is different from traditional round sable brushes. When the hair bristles of a bamboo round are splayed to create uneven ends, it is a marvelous tool for creating textures such as tall grass, tree foliage and various other textures found in nature.

In Oriental painting and in the work of many contemporary watercolorists, individual brushstrokes are valued for their intrinsic meaning or for their part in the overall design pattern. Artists following that approach tend to leave their brushstrokes undisturbed. Other artists leave few brushstrokes undisturbed for long. As they paint, they constantly overlay earlier brushwork with newer

washes until, in most cases, individual brushstrokes are no longer recognizable but mesh into larger naturalistic forms.

This technique demands a delicate balance because if overused, it can quickly become repetitive and uninteresting. Quite often, one or more clean, clear brushstrokes within the area are necessary to lend interest, direction and variety.

Sample Textures Created With a Bamboo Brush

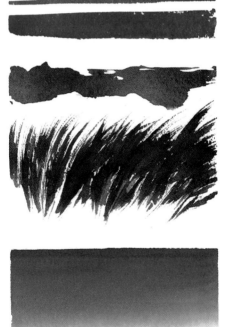

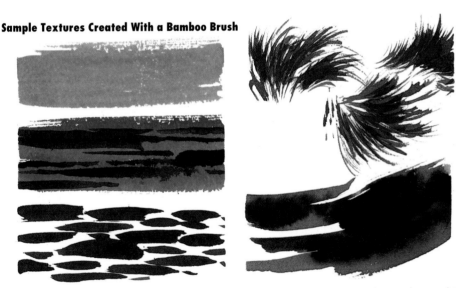

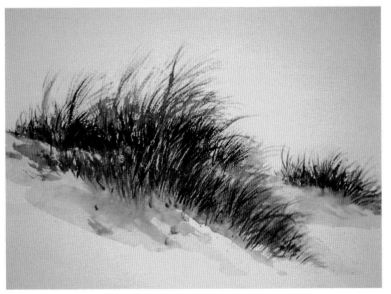

A dune and grass study shows effects created with a bamboo brush.

Round Brush Exercises

Get out your biggest *round brush* and make a big puddle of color on your palette—you'll need a fair amount to try out this brush to the fullest. Fill the brush with a good, wet load.

Press the brush firmly onto the paper, holding it upright, or just skim over the surface with the handle close to the paper. (The angle at which you hold a brush makes a big difference in the marks it makes.) Whatever you can think of to do, try it.

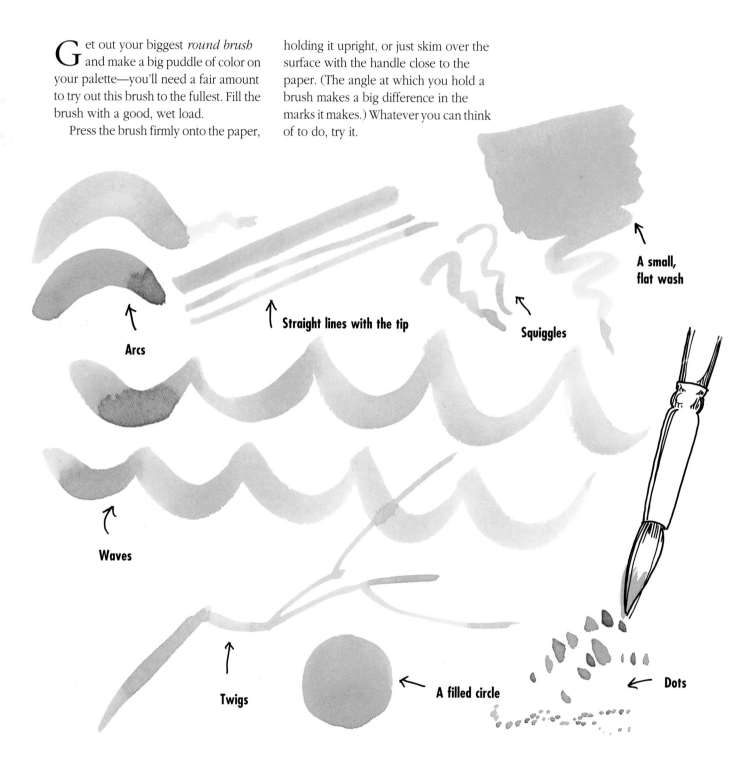

A small, flat wash

Straight lines with the tip

Squiggles

Arcs

Waves

Twigs

A filled circle

Dots

Flat Brush Exercises

Now try out your *flat brush* the same way. By its very shape it does well with geometric forms but experiment to see what else it can do. It's amazingly versatile.

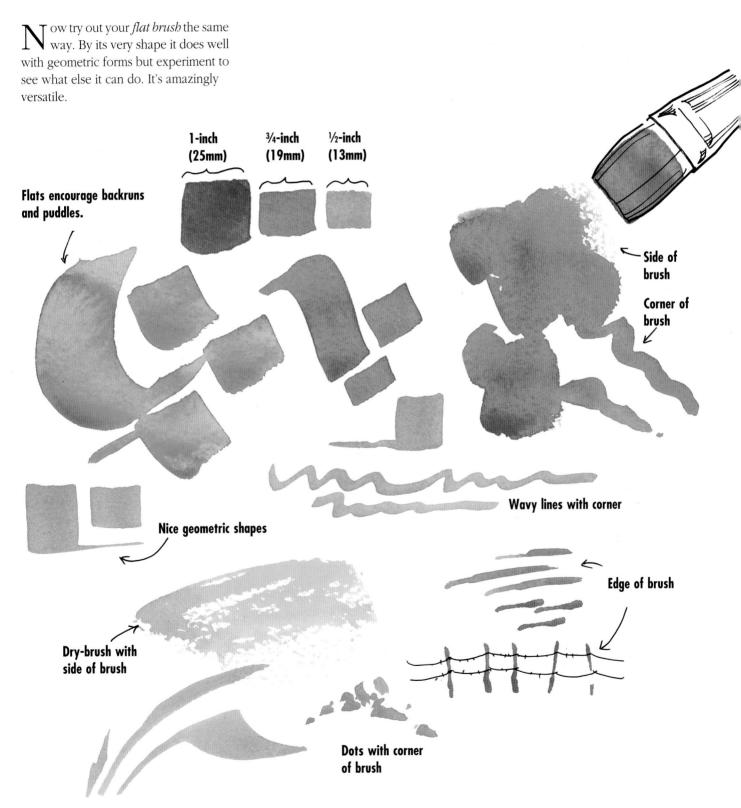

1-inch
(25mm)

¾-inch
(19mm)

½-inch
(13mm)

Flats encourage backruns and puddles.

Side of brush

Corner of brush

Wavy lines with corner

Nice geometric shapes

Edge of brush

Dry-brush with side of brush

Dots with corner of brush

Rigger Brush Exercises

S ee what kinds of marks your *rigger* can make—it's not just for lines, you know. Wiggle it; spread the hairs; make dots. It makes a nice, dancing line for twigs, too.

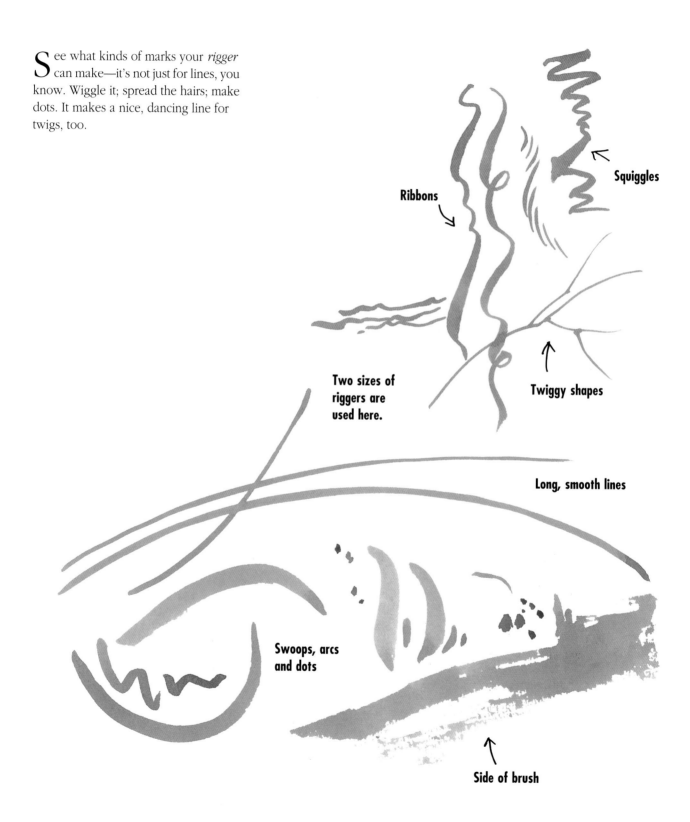

Squiggles

Ribbons

Twiggy shapes

Two sizes of riggers are used here.

Long, smooth lines

Swoops, arcs and dots

Side of brush

Fan Brush Exercises

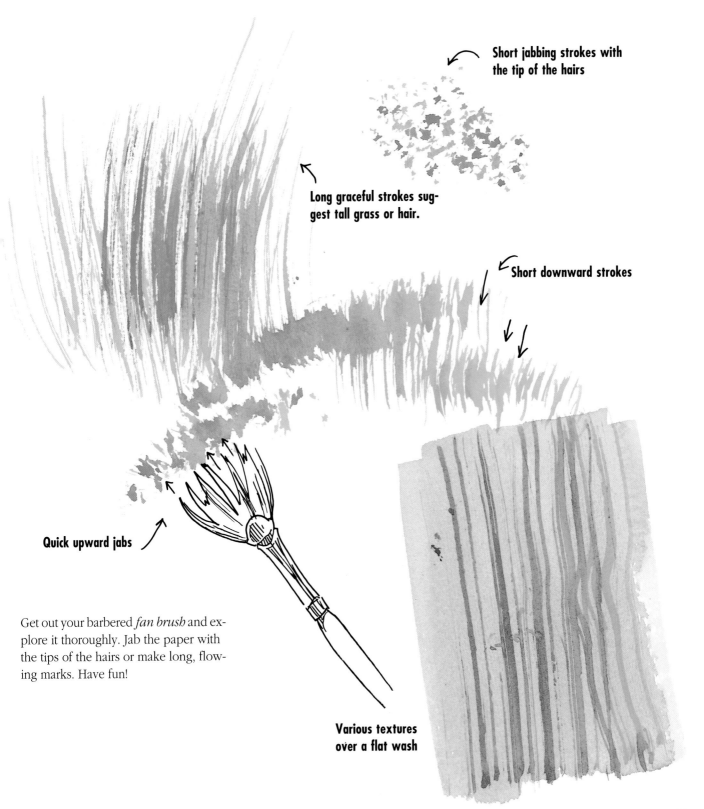

Short jabbing strokes with the tip of the hairs

Long graceful strokes suggest tall grass or hair.

Short downward strokes

Quick upward jabs

Get out your barbered *fan brush* and explore it thoroughly. Jab the paper with the tips of the hairs or make long, flowing marks. Have fun!

Various textures over a flat wash

Stencil Brush Exercises

Try out your *stencil brush* for spattering. Touch it to a pool of paint, then rub your thumb over the edge. Aim it directly at your paper or at an acute angle. Blot some of your dots with a tissue. Try painting with this brush, too. You won't have a lot of control for details, but it makes nice, loose, rough-edged shapes.

(Yes, you do get a colored thumb!)

Held at acute angle to the paper

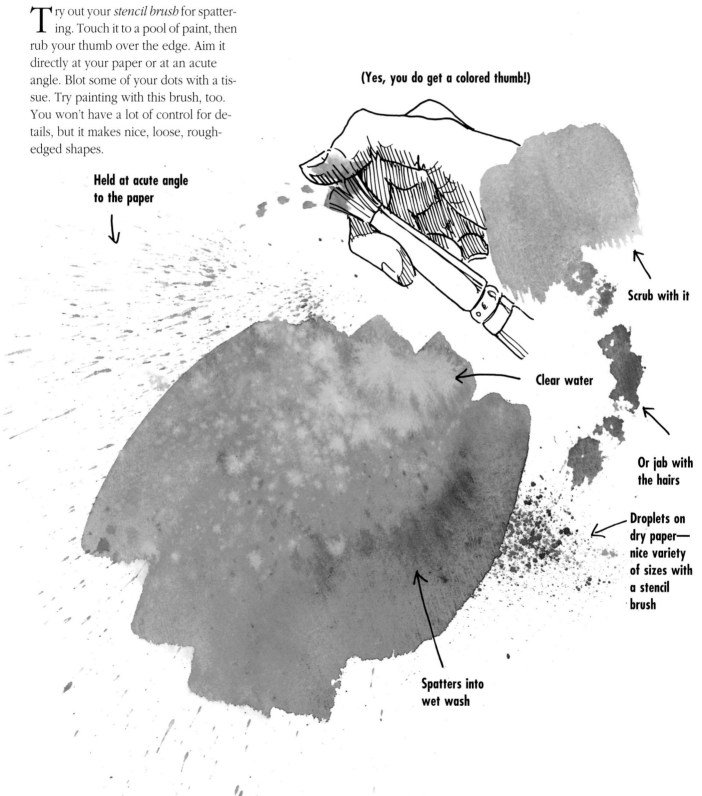

Scrub with it

Clear water

Or jab with the hairs

Droplets on dry paper— nice variety of sizes with a stencil brush

Spatters into wet wash

Exercises With Other Brushes

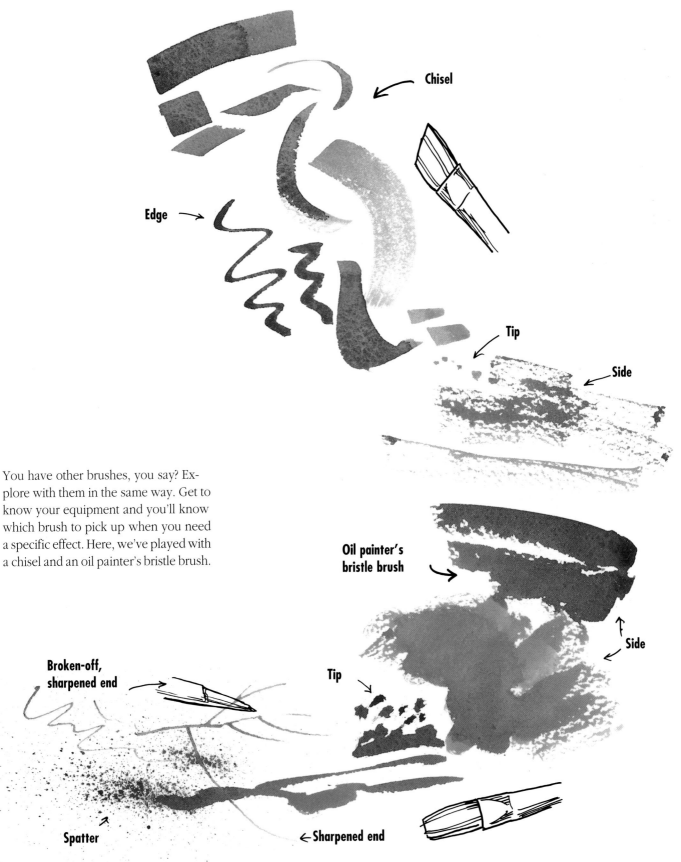

Chisel

Edge

Tip

Side

You have other brushes, you say? Explore with them in the same way. Get to know your equipment and you'll know which brush to pick up when you need a specific effect. Here, we've played with a chisel and an oil painter's bristle brush.

Oil painter's bristle brush

Side

Broken-off, sharpened end

Tip

Spatter

←Sharpened end

Assorted Tool Exercises

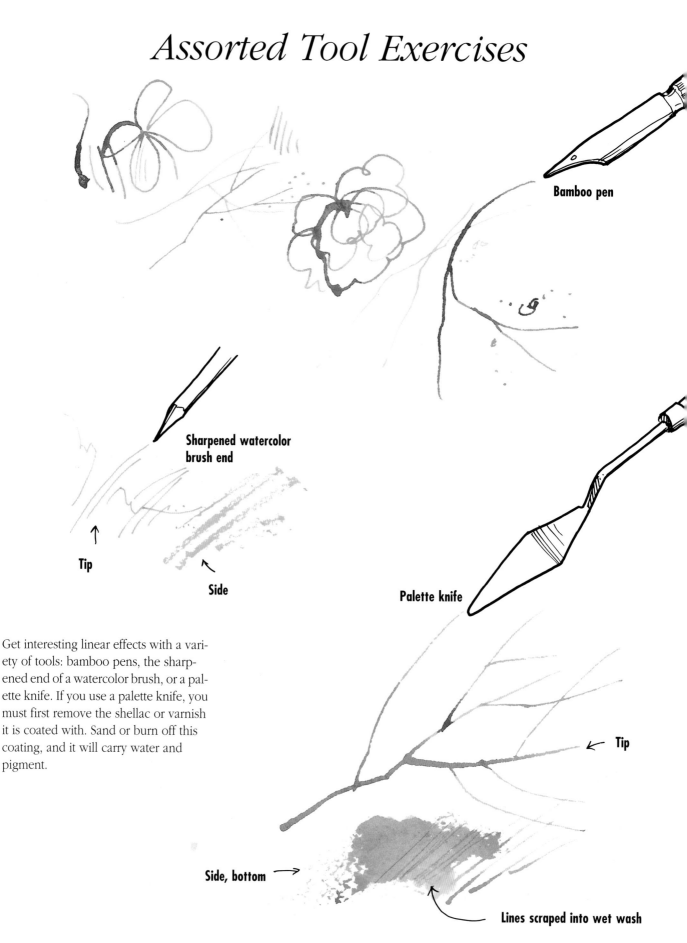

Bamboo pen

Sharpened watercolor brush end

↑
Tip

Side

Palette knife

Get interesting linear effects with a variety of tools: bamboo pens, the sharpened end of a watercolor brush, or a palette knife. If you use a palette knife, you must first remove the shellac or varnish it is coated with. Sand or burn off this coating, and it will carry water and pigment.

← **Tip**

Side, bottom →

Lines scraped into wet wash

Basic Techniques for Painting Textures in Watercolor

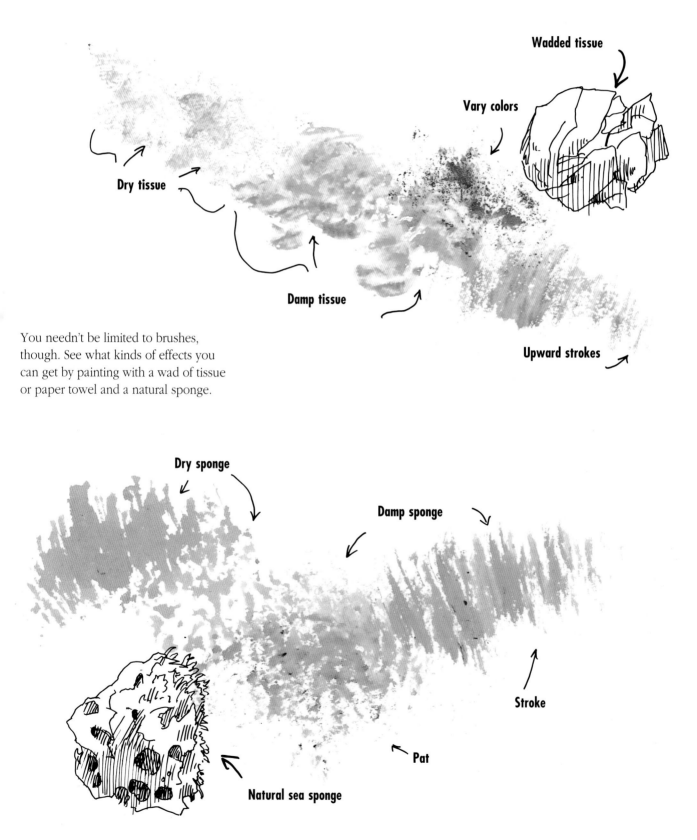

Wadded tissue

Vary colors

Dry tissue

Damp tissue

Upward strokes

You needn't be limited to brushes, though. See what kinds of effects you can get by painting with a wad of tissue or paper towel and a natural sponge.

Dry sponge

Damp sponge

Stroke

Pat

Natural sea sponge

Techniques for a Variety of Surface Textures

Dry Surface Techniques

Drybrushing (moist paint applied to a dry surface) produces crisp-edged lines and paper-induced textures as the brush dries out.

Round detail brush stroked over dry paper.

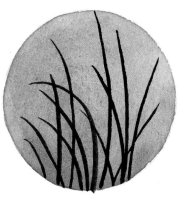

Round detail brush stroked over a dry wash.

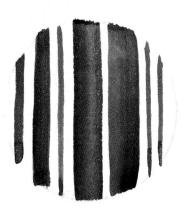

Flat brushes stroked over dry paper surface.

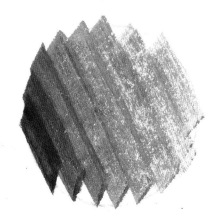

As moisture leaves flat brush, paper texturing occurs.

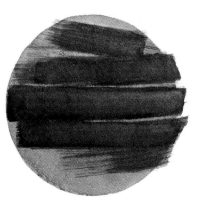

Flat brush stroked over a dry wash.

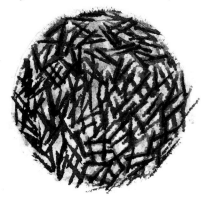

Edge of flat brush stippled over a dry, mottled wash.

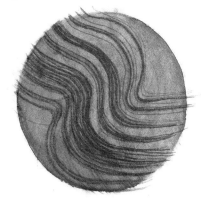

Fan brush stroked over a dry wash.

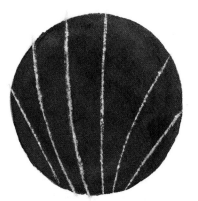

Lines scratched into a dry wash with a razor blade.

Damp Surface Techniques

Pigment spreads easily when stroked over a moist (not shiny) surface, producing softened edges and smooth blends.

Round and flat brush strokes on a damp paper surface.

Varied washes on a damp surface. Note smooth blending of hues.

Stroking the edge of a damp wash with a clean, moist brush produces a gradated blend.

Bruising the paper with a stylus causes the pigment in a damp surface wash to gather into dark lines.

Scraping through a near-dry wash with a blunt tool creates lightly pigmented designs.

White area protected from damp surface wash with masking tape.

White design area masked with Liquid Frisket.

Liquid Frisket applied over a dry wash, followed with a darker, damp surface wash.

Wet-Into-Wet Techniques

M oist paint applied to a shiny wet surface will flow freely, creating soft, feathery designs.

Spontaneous design resulting from wet-into-wet application.

Flat and round brushes stroked over a wet surface.

Spontaneous mixture of varied hues applied to a wet surface.

Directional flow from tilted paper.

Pigment-filled round brush touched to wet surface.

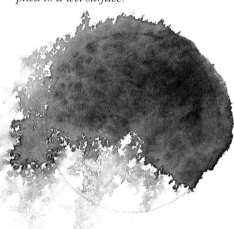

Edge of wet-into-wet wash sprayed with spray mister.

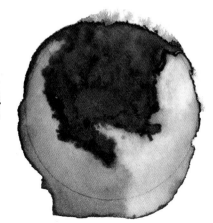

Puddling occurs when additional liquid is applied to a wet-into-wet wash.

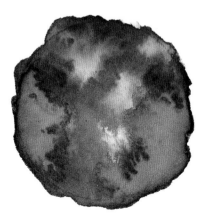

A water-filled round brush touched to a wet, varied wash.

Blotting Techniques

A bsorbent materials pressed into a damp to wet wash will lift the pigment creating negative designs.

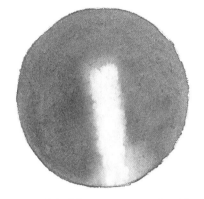

Pigment lifted from a moist wash with a damp flat brush.

A near-dry wash worked with a damp flat brush and lifted with a tissue.

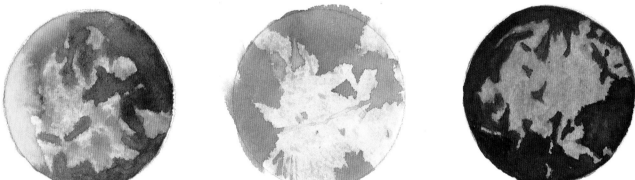

Moist washes blotted with a crumpled paper tissue.

A damp surface wash blotted with a paper towel.

A varied wet-into-wet wash blotted with a paper towel.

Dry, multilayered wash worked with a damp brush and lifted with a tissue.

Impressed Textures

F oreign materials laid into a moist wash and left to dry completely will draw and hold the pigment, creating dark print-like designs.

Crumpled wax paper weighted down

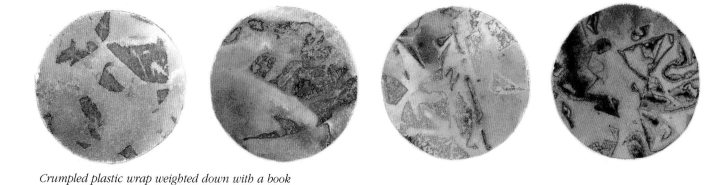

Crumpled plastic wrap weighted down with a book

Crumpled tin foil　　　*Sewing thread*　　　*Fine hairs from a chow dog's inner coat. (Pat into place with a brush.)*

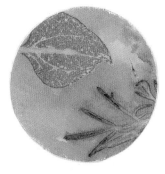 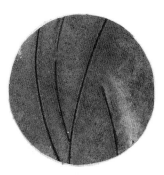

Spring leaves　　　*Toothpicks*　　　*Coarse sand*　　　*Horse tail hairs*

Salt and Alcohol Techniques

Introducing rubbing alcohol or salt into a very damp to wet wash will displace the pigment, creating pale designs. Under humid conditions, dry the salt in an oven or microwave before use.

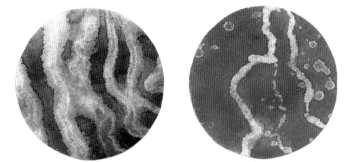

Rubbing alcohol applied with the tip of a round detail brush.

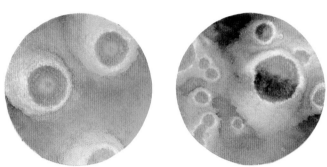
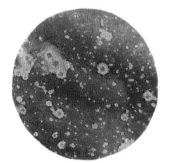
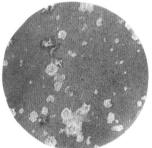

Large drops of alcohol dripped into a moist wash from the tip of a brush.

Fine drops of alcohol spattered into a moist wash.

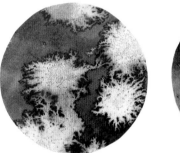
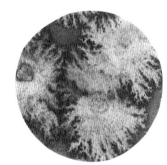
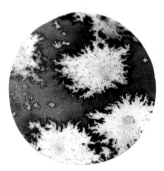

Wet pieces of rock salt laid into a moist wash and left until dry.

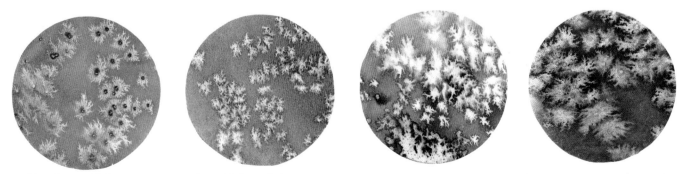

Table salt sprinkled into a moist wash and left until dry.

Spatter

**Directional spatter
flicked off a fingertip
with a flat, stiff brush**

When paint is flicked, flung or sprinkled onto the paper, random spatter patterns are formed that have a dusty, crumbly, gritty or pebbly texture. Directional spatter has the look of exploding motion.

Wet-into-wet spatter

**Layered spatter over
dry surface**

**Blotted
spatter**

Paint flung from brush

**Drops of
sprinkled
wash over
fine spatter**

**Wet wash sprayed
with clear water**

**Water drop marks on
damp and wet surface**

**Liquid Frisket spattered
beneath a light wash**

Basic Techniques for Painting Textures in Watercolor

Sponging and Stamping

Sea sponge wiped across paper surface

Printed on dry paper with a pigment-filled sea sponge

Sponging

Layers of sea sponge printed over a damp wash

Printed with a damp man-made sponge that has been brushed with varied colors. As the sponge loses moisture the design becomes more distinct.

Stamping

Stamping is the process of imprinting a texture or design on paper. Brush fresh leaves with pigment and press on a dry paper surface to achieve the effect shown at right.

Add Sparkle With Spatter, Sprays and Runs

Spatter

The light midtone of the ground plane in *Adobe Abode*, while still moist, was modulated by flicking in paint with a bristle fan brush and using fingers to flick in clear water. The result is a pleasing textural effect with a variety of marks used to suggest foreground activities. By repeating this procedure once the area is dry, the resulting spatters are hard edged. Some artists knock a loaded brush against another brush to flick paint spatters into areas to be modulated.

Spatter Creates Possibilities *The artist spattered paint from a loaded brush onto the pale foreground. The effect draws your eye to the site and suggests possibilities beyond the subject of the painting.*

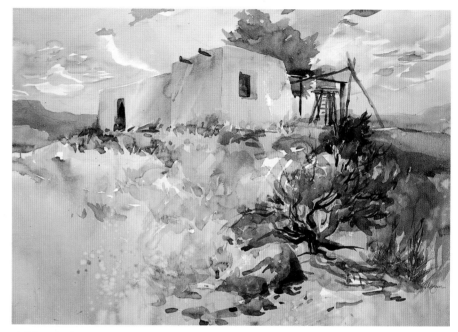

Adobe Abode
22" × 30" (55.9cm × 76.2cm)
Judi Wagner

Sprays and Runs

Spraying a mist of water using a spray bottle can soften an area or add texture to a plain wash. Notice the softening effect of the spray on the green at the top of *Marina*. Using the spray technique can be the touch that completes an idea.

Runs are created when your watercolor runs with or without control. Used wisely, runs produce interesting texture.

Texture in *Marina* *The artist sprayed the top of this painting to soften and texturize the green. He also used runs on the lower part of the painting.*

Marina
22" × 30" (55.9cm × 76.2cm)
Carl Vosburgh Miller

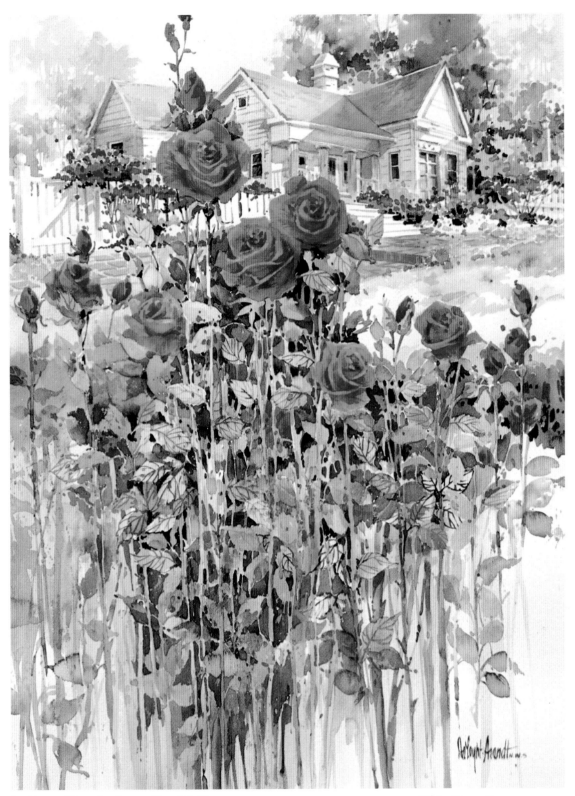

Spatter and Runs Can Loosen Up a Painting
*The artist uses intentional runs to create
the stems and to loosen up an area that she
finds too tight.*

White House Roses
30" × 22" (76.2cm × 55.9cm)
Mary DeLoyht-Arendt
Collection of
Dr. Kathryn Kendall

Using Runs in Your Design

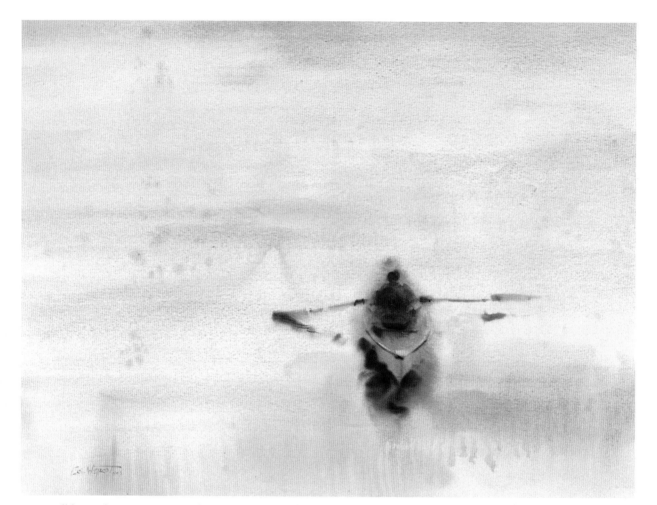

We've all been there. You've got this beautiful painting going when your colors start running. Before wiping up runs with a thirsty brush, realize that those runs may not be the problem you think. Let them go, and perhaps they'll become minimized as the painting develops. Or maybe this run can be capitalized on.

You can even plan for runs and anticipate them. If a puddle of paint accumulates at the bottom of a wash, just add a little water. Once the surface tension is overcome, it will run. Or just make the angle of your board steeper to initiate the run. Learn to see runs as potential parts of your design.

Look at watercolors up close to see elements like runs. You can see the artist at work this way. Keep in mind that timidity leads to dead painting; freshness and life come from putting anxiety aside, allowing you to paint freely and confidently.

A painting instructor had a good way of putting it: "Don't let your painting know what you're thinking." Decisiveness will win the day. Make your strokes strong, free and direct, and let texture happen.

First Take *Working from a photograph and graphite value studies, the artist laid down an evenly graded wash of Raw Sienna, Cadmium Yellow and Cobalt Violet for this piece. Next came the boat and figure on damp paper. After letting the painting rest for several days, he decided that it needed additional texture on the left side.*

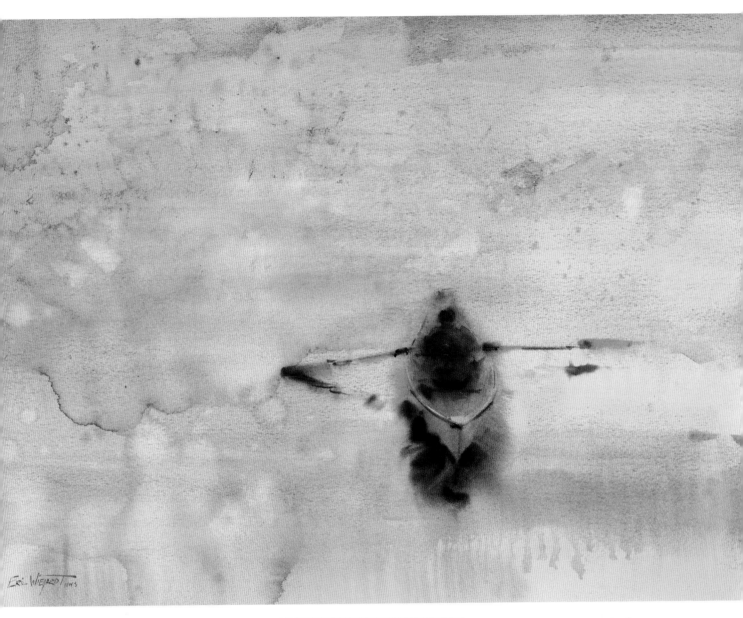

After Decisively Adding Texture *The artist rewet the paper, then let it dry to the point when further application would cause a desirable, yet unpredictable, creeping of pigment. The artist dropped in Cerulean Blue, allowing the process to begin, manipulating and tilting the board for guidance.*

*G*reat works of art should look as though they were made in joy. Real joy is a tremendous activity, dull drudgery is nothing to it.

—Robert Henri

Larry
Eric Wiegardt

Various textures in Sierra Penstemon *were created by spattering and by "flooding" semi-dried washes with water to cause runs and staining along the edges of the washes. Most artists are taught early on that such "stains" shouldn't happen in paintings; but under the right circumstances the textural result, especially on rock forms, can be quite effective.*

Detail of Sierra Penstemon
Robert Reynolds

Basic Techniques for Painting Textures in Watercolor

Raindrops—Natural Spatter

Have you ever been on location and dreading the effects of the weather: too cold, too damp, too dark? Nature seldom adjusts to the artist. Since you can't change nature, you can either quit outdoor work or learn to gather information no matter the weather.

Try to deal with the forces of nature as a positive creative experience. You can either sketch and bring ideas back to the studio, having experienced the subject with more senses than just your eyes, or accept nature's contributions to your painting. For example, raindrops sometimes reach a painting and become part of the design.

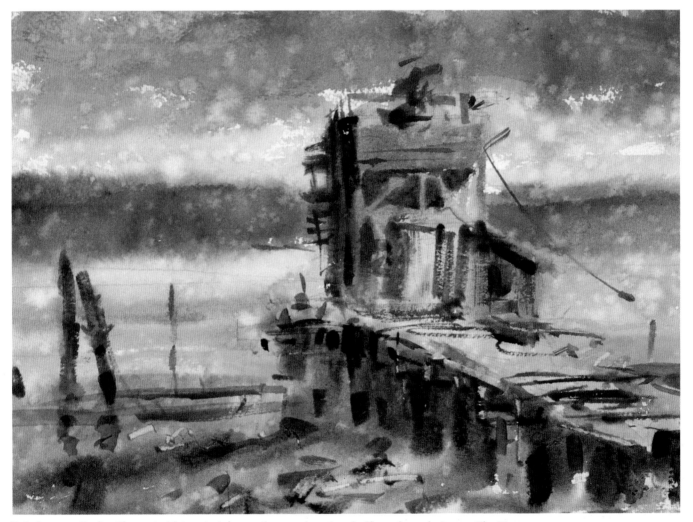

Raindrops as Design Elements *This painting was done on location; halfway through, it started to drizzle. The artist decided to continue, letting the raindrops become part of the design.*

The Hopper
Eric Wiegardt

Expressive Gesture

You can have some interesting conversations with artists as to whether or not they like their touch to show in their work. There are two schools of thought. Artists of the first school argue that the viewer's focus ought to be on the image, not the paint quality. They want the viewer to have an immediate response to *what* they say, not *how* they say it. To them, texture and technique should be secondary at most, and perhaps it is even better if they are completely unnoticeable.

The second position argues that brushwork and gesture are an artist's signature. Proponents of this view believe it's important to see the artist's hand. They would argue that *how* artists say what they say is critical to the message, enhancing and emphasizing the content of the painting.

Attention to Subject *(top left) A work of art devoid of the artist's hand will focus immediate attention on the subject being portrayed. Here McVicker's brushwork is all but invisible through intense work and layering. For him, the inclusion of visible gesture depends on the subject at hand.*

Red and White Rhodies
24" × 18" (61cm × 45.7cm)
Oil
Jim McVicker
Collection of Mr. and Mrs. Daniel Jacobs

Expressive Gesture *(bottom left) For Kessler, expressive gesture and form are fundamental to his work. The markings and visible pulls are an integral part of each piece and are extremely important to the overall effect of the finished painting.*

Untitled
14" × 22" (35.6cm × 55.9cm)
Acrylic on paper
Michael Kessler

The Artist's "Hand"

Whether you choose to *emphasize* gesture or not, you will definitely establish a texture of some sort, and this touch gives an inner life to a work of art.

The importance of texture is evident everywhere. Imagine for a moment that all fabric looked alike or that all food had the same consistency. There would be little individual character. Different textures stimulate our senses and provide satisfaction and pleasure of their own. This is the case in life *and* art.

Every time you apply color to paper or canvas, you set up a decorative pattern or visual texture across the surface of the picture plane. Just as no two people have the same handwriting, no two artists apply their medium in the same way. Some paint application techniques are more pronounced than others and therefore create a more obvious textural effect. We can see this in the illustrations below. An artist's choice of materials and application is the key to these stylistic effects.

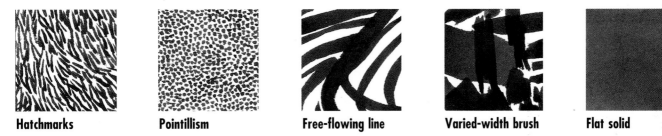

| Hatchmarks | Pointillism | Free-flowing line | Varied-width brush | Flat solid |

Different Paint Applications Create Different Surface Feelings *Step back from your brushmarks and notice them as texture. As individual as handwriting, each brush style has a different textural feeling. Observe the difference between the controlled activity of pointillism and the dynamics of the varied-width example.*

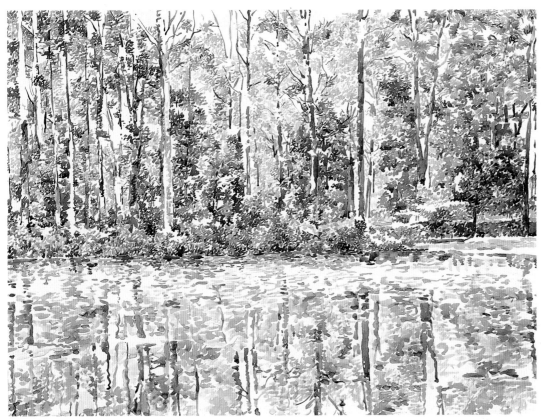

Open Weave Approach to Texture *In this watercolor, Engel establishes a unified textural surface across the whole work. This pattern creates an underlying abstract repetition that pulls the viewer through the work. Regardless of subject, color or value, Engel's application transforms a flat surface into a patterned surface through which the eye can weave.*

Botanical Garden
22" × 30" (55.9cm × 76.2cm)
Watercolor
Charlene Engel

A Variety of Personal Textures

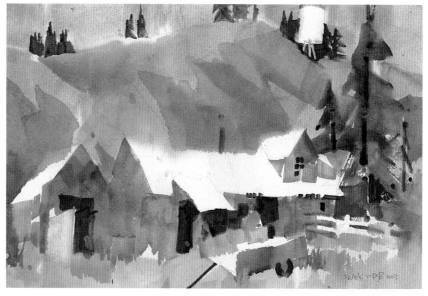

Charlene Engel's broad strokes, David Richards's pointillist dots, Frank Webb's watercolor washes over large areas of flat mass and weight—all of these application techniques have this in common: Texture is created as the color is applied. By modifying this texture slightly throughout a painting, you can enhance the rhythm, focus and sensory appeal while maintaining an individual look. Within the same canvas there are many ways to heighten texture. You can control the density by opening and closing the weave, varying the length, size, shape and direction of the strokes, or combining brushwork with other gestures, such as finger work or flinging paint.

Personal Texture *Both of these paintings are rendered in watercolor, but each carries a very different textural quality. The static calm of Richards's pointillism and the expressive freedom of Webb's wash are just two samples of the seemingly limitless approaches to personal texture.*

Volcano
15" × 22"
(38.1cm × 55.9cm)
Watercolor
Frank Webb

Double Illusion: Across Paris Skies, 27" × 40" (68.6cm × 101.6cm), David P. Richards, Collection of Stefanie Field

Basic Techniques for Painting Textures in Watercolor

With oil and acrylic paint, you can actually build up the surface texture three-dimensionally; this is called *impasto* painting. In impasto, you apply the paint so heavily that you create a relief surface that can be seen. You can actually build up the paint to help form the shape of the subject itself. Tension is established in impasto work by using high and low areas side by side. Isolated areas of impasto can move an object forward, while thinner, flatter areas recede.

You can use sand or other additives to thicken or change its texture. Other elements, such as the nature of the painting surface and the spring or firmness of the instruments used, will contribute to textural impression. All of these factors converge in a personal approach that causes the viewer's senses to respond.

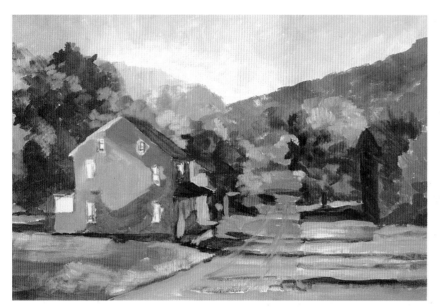

Acrylic Underpainting for
Mahoning Valley Road

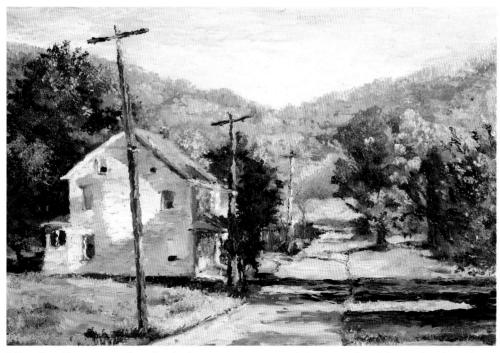

Mahoning Valley Road
24" × 16" (61cm × 40.6cm)
Oil
Edith Roeder

A Two-Step Process *Roeder's finished impasto painting style begins with a fully rendered acrylic underpainting shown above. She began using this two-step process because it provided a better map than a simple line drawing did. It also helps her to lay in a quick oil top coat that isn't reworked or adjusted and therefore retains a fresh, clear color.*

Make Texture Your Main Subject

DEMONSTRATION — Carol Surface

With most paintings the artist has a subject to direct the process. What provides the direction and momentum when there is no subject?

For Carol Surface the painting is driven by the movement of the paint itself and the challenge of textural design. She says, "The whole idea is reacting to the paper and the paint and the textures and shapes you make with them."

Surface starts with color and shape, setting one or two compositional goals before she begins. Then she starts to pour color onto her paper, and she lets the paint itself lead to each new step of the painting.

She varies her palette from painting to painting, trying not to keep reaching for the same few colors over and over. She says, "It really does come down to 'I feel red today' or 'I feel blue today.' Sometimes I mix colors to pour and then use totally different colors. To challenge myself, I might choose unusual colors, and I don't know how they'll go together."

The Elements of Textural Design

Interesting texture and design are essential in nonobjective painting. This is best achieved by painting studies of shape, value, color, line, texture and so forth. If you are diligent in your efforts to practice these concepts, they will eventually emerge unconsciously in your paintings in a solid and interesting design.

Step One

Surface began this painting with no subject in mind. She poured Permanent Rose, French Ultramarine Blue and Burnt Sienna onto wet paper. Then she brushed it away, scraped it with a credit card and lifted it with toilet paper until it began to take on an energy that she liked.

FIVE ELEMENTS TO LOOK FOR

1. *Variation.* Shapes should not be too even. Lines should not all flow in the same direction. Textures should vary.
2. *Energy.* The shapes, lines and textures should be exciting by themselves.
3. *Deliberateness.* Paint applications should never look accidental or ambiguous.
4. *Continuity.* The shapes, colors, textures, etc., must look like they belong in the same painting.
5. *No points or sharp angles.* Unless you want the eye to go in a particular direction, these should be avoided.

Basic Techniques for Painting Textures in Watercolor

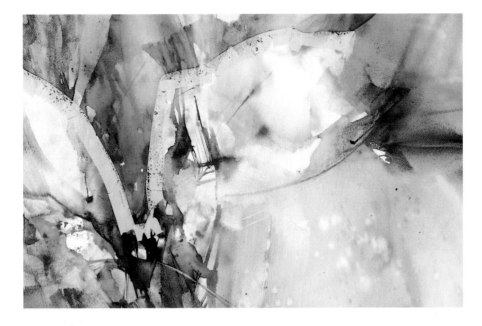

Step Two

Surface saw a vague suggestion of butterfly wings in the pigment and decided to take that further. With masking tape she marked off the area that would be the lighter wings and added more color above the tape.

Step Three

She began to intensify the rest of the painting working wet-into-wet with lots of paint and not much water. Painting on Winsor & Newton paper with heavy sizing, she was able to add more washes and lift color off where it was too heavy.

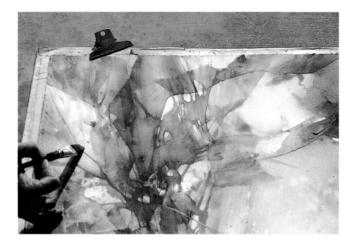

Step Four

Surface used the technique of painting over wet media acetate to try out an intense yellow in the left wing shape. She didn't like the effect. Since she was not painting directly on the paper, she was able to simply remove the acetate.

An important design element Surface checks for is dominance. She explains, "I think of it as the word 'mostly' and ask: Are the shapes mostly angular or curvilinear? Are the textures mostly hard or mostly soft? Is the painting mostly warm or mostly cool? If it waivers between the two, I push it toward one or the other."

She tests the design as she paints by placing an L-shaped half mat over each quadrant. Each section of the painting must have a pleasing design that holds together.

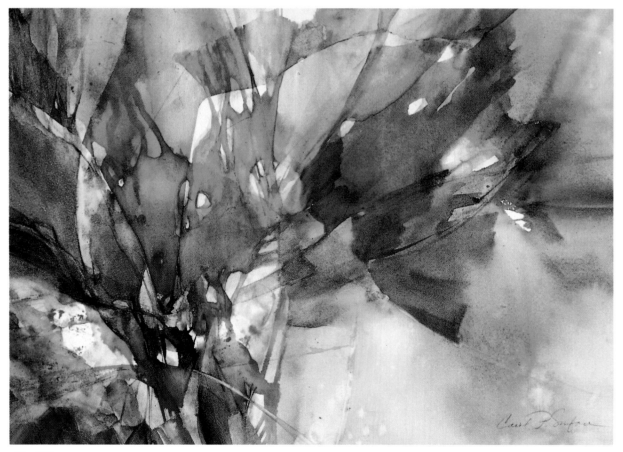

Wind Weaver
15" × 22" (38.1cm × 55.9cm)
Carol Surface
Collection of Mr. and Mrs. Ron Burman

Basic Techniques for Painting Textures in Watercolor

Two More Abstracts

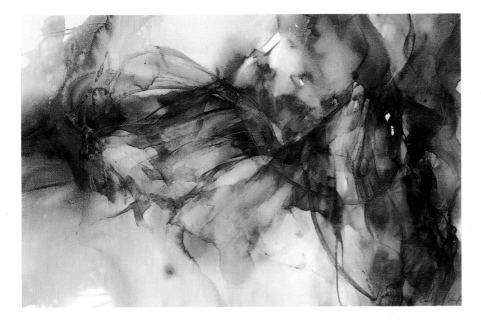

Starting Over *Even when she begins with an idea for the design or color, Surface does not feel obligated to continue in that direction. With this painting she says the first attempt looked like "just a lot of beautiful paint." So she took it outside and hosed it off. The shapes that remained suggested the finished painting.*

Life Journeys
29" × 45" (73.7cm × 114.3cm)
Carol Surface
Collection of Max and Naida Shaw-Kay

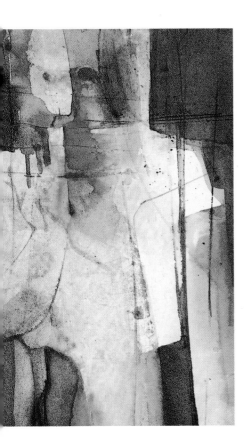

SOME COMMON MISTAKES

What are common flaws in abstract paintings?

1. *No darks.* Beginners are generally afraid of the dark. You have to have strong values to give an abstract painting power.
2. *Sloppy strokes.* The strokes just kind of end out in the middle of nowhere as if the artist didn't bother to complete them.
3. *Overbrushed surface.* Don't brush the painting to death. Put on your paint and leave it there.
4. *Lack of conviction.* This especially shows up in not using enough paint when you put the darks on. Be bold. That bravery will make you look a lot more experienced than you may be.

Color and Composition Are Primary

Surface says it's not necessary for the viewer to see the subject. With abstract work, the color and composition must be exciting enough to please whether there is literal imagery or not.

Private Dancer
6½" × 4¾" (16.5cm × 12.1cm)
Carol Surface
Collection of Ms. Terylann Knee

Texture in Edges and Lines

Consider edges to be tools for using texture to describe form. To give the illusion of a slow change in form, value or color, use a soft edge; for a rapid change in form, value or color, use a hard edge. Hard edges are more noticeable, drawing the eye to a particular area, while soft edges make the junction of shapes less prominent.

Look at a shape's boundaries, or edges, as opportunities for expression. Watercolor, with its spontaneity, lends itself especially well to beautiful edge quality. Be adventurous. Open yourself to the possibilities.

Hard Edge *The hard edge was created by applying the gray color after the red had dried, producing a hard, broken edge.*

Broken Edge *As this stroke progressed to the right, the artist allowed the brush to lie down horizontally, thus skipping on the "hills" of the paper, causing a broken edge.*

Soft Edge *With clear water laid down, allow two colors to mingle for a soft edge.*

Erased Edge *Use an eraser to remove the Cobalt Violet and create a soft edge.*

Scumbled Edges *Scumbling produces a variety of edges by pushing paint-filled bristles against dry paper.*

Varied Edges *Variation within strokes adds beauty and depth.*

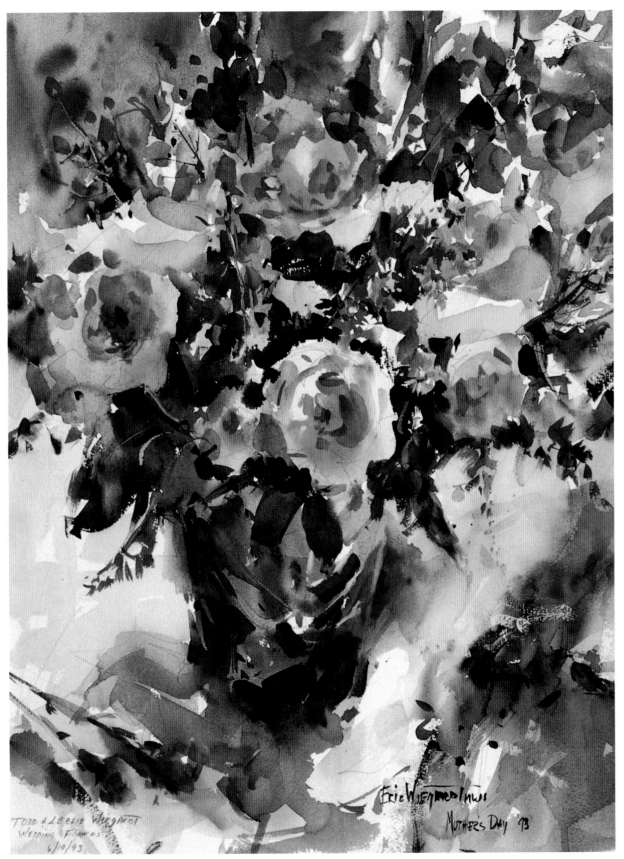

Expressive Edges *A variety of edges throughout a painting is a powerful, expressive tool. Try to run the gamut from razor sharp to lost and soft.*

Todd and Lezlie's Wedding Flowers
Eric Wiegardt

How Paper Wetness Affects Texture

An element of exciting edge quality is transitional degrees of paper wetness. Begin by laying down some washes on dry paper (areas should vary in dampness, so don't put an initial wash over the whole paper). Drop in other shapes and lines on top of those washes as the paper begins to dry. A stroke may go over a damp area, producing a soft edge, and end over a dry area, producing a hard edge. Make quick judgments, because decisions about each stroke demand an intuitive response rather than a calculating one. Besides, a stroke that loses its shape because it runs into an area that is too wet can be redefined at a later time when the paper is drier (the combination can be beautiful). This situation—in which surface areas are drying at different rates—is called transitional degrees of wetness. This process may seem out of control, but it produces an endless variety of beautiful edges.

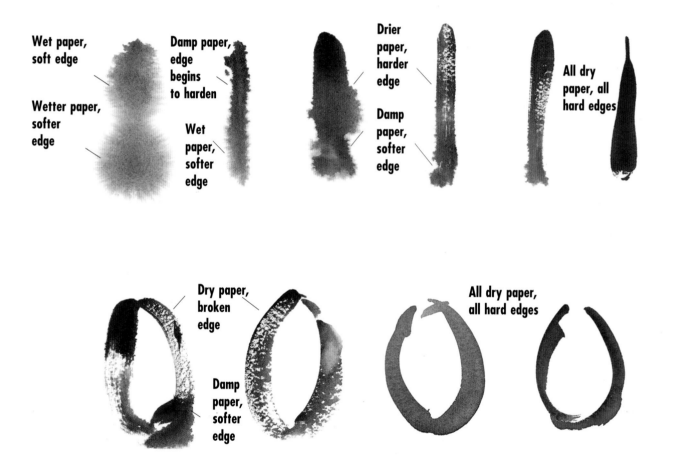

Wet paper, soft edge

Wetter paper, softer edge

Damp paper, edge begins to harden

Wet paper, softer edge

Drier paper, harder edge

Damp paper, softer edge

All dry paper, all hard edges

Dry paper, broken edge

Damp paper, softer edge

All dry paper, all hard edges

Wet the paper with clear water and follow with strokes applied as the paper dries, starting with the top row on the left, and ending with the bottom row on the right. Notice the interesting variation of effects, especially the beauty of a stroke passing through both a damp area and a drier area. In your painting, lay down some initial washes, then work in additional strokes as the paper dries. The brush will pass through varying degrees of dampness, creating attractive variations in edge quality. These edges can be unpredictable, but that is part of their charm.

DESIGN AND SPONTANEITY

Using transitional degrees of wetness is like jumping into cool water. But don't simply plunge. Balance design and impulse. Produce a watercolor both poised and spontaneous, exhibiting freshness and structure.

Edge Quality

Step One
Paint Through Similar Values

Wiegardt blocked in the flower mass with one wash on dry paper, allowing the shapes to blend, mixing in touches of Cobalt Blue and Cadmium Red for variety.

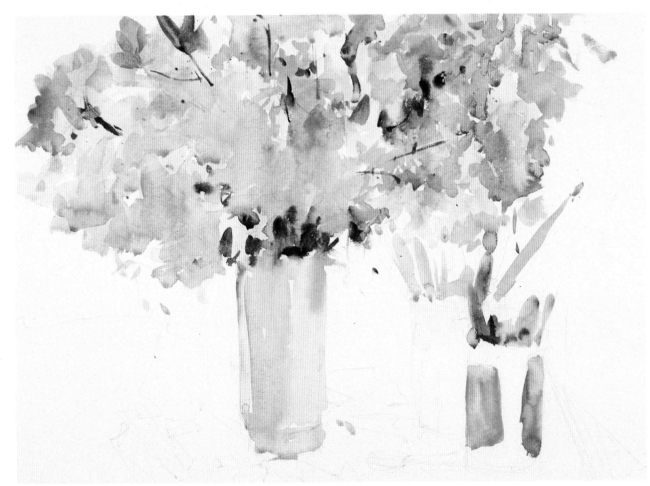

Step Two
Transitional Degrees of Wetness

By holding up the paper and looking at it from an angle, the artist can see that the sheen is gone and the initial wash is in the damp stage. He begins dropping in the warm shadow masses of the azaleas, and some rich darks, allowing the variety of edge quality to be determined by the dampness of the paper. In areas where the paper is slightly drier, the edges are more crisp; they run together in the wettest parts. Because he works with his painting board at an angle, the upper portion of the initial wash dries first, creating harder edges sooner with successive washes.

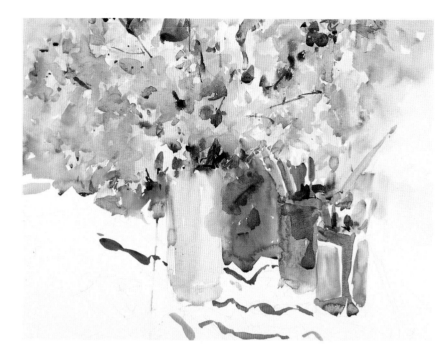

Step Three
More Edge Variation

Notice the vertical wash of blue to the right of the vase shape. Do you see how the edge softens where the wash of the vase was still damp, and then hardens where it was dry? This kind of variation adds spontaneity to a painting. Allow it to happen. You can always come back later and redefine if necessary.

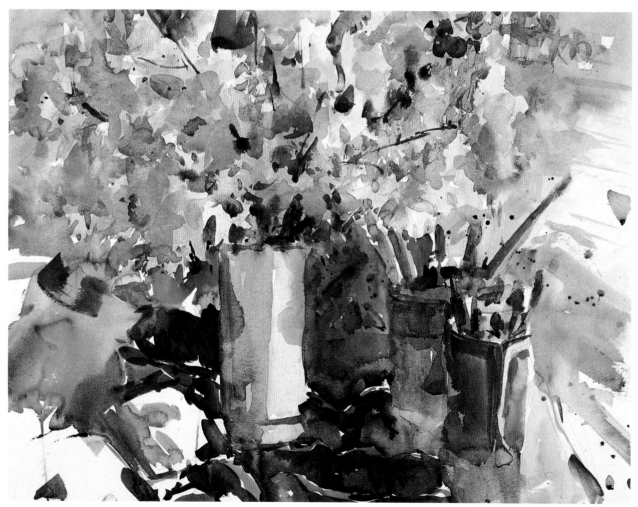

Step Four

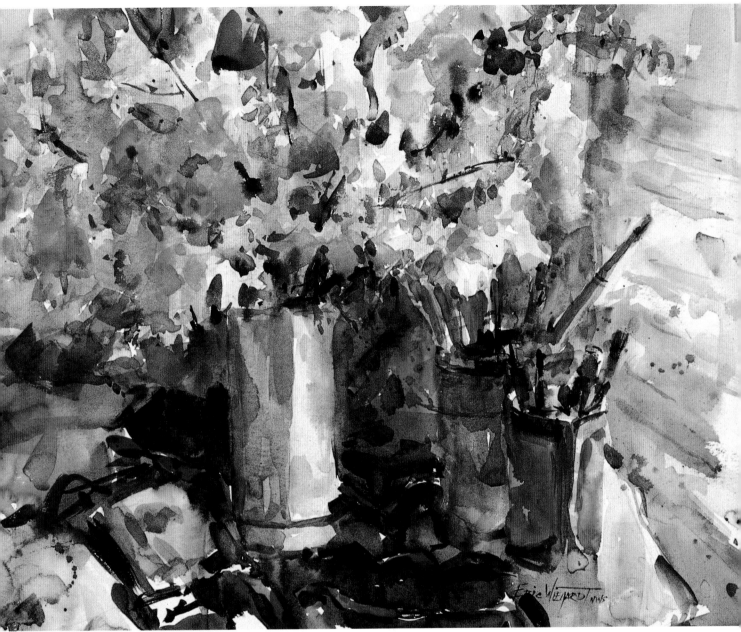

Step Five

Bonnie's Azaleas
Eric Wiegardt

Step Four
Still More Variation

Starting to block in other objects, allow the washes that come across the damp paper to mingle. The edges remain harder where the paper is dry. The loose effect is refreshing. Definition can come later. The bottoms of the cans were done when the paper was damp. Notice the mingling of color and soft edges.

Step Five
Redefine Your Shapes

Overlapping strokes are used in the foreground.

Using Lines and Edges

It is always tempting, when shapes and values are not quite coming together, to define these forms by drawing lines around them. But overuse of line to demarcate boundaries causes a painting to lose its sense of depth and appear flat. A lack of good edge quality makes a painting appear childish, amateurish. Lines function in a painting as design elements, so reserve them for this purpose. Use value to show separation between shapes, and lines for their design function.

Line Work Is Art in Itself *Notice the variety and change in these quick gestures of cows, a goose and a ballerina. Some lines are solid, others broken. Some statements (such as the ballerina's right hand) are left incomplete, yet sufficiently complete for the mind to recognize.*

No Lines Required *Form and depth are determined by changes in value and overlapping. Line work is not necessary to mark the boundaries.*

Unclear Value Pattern *The value pattern here is unclear. Line has been used to give form to the structures, resulting in a flat, amateurish look. Use line as a design tool, rather than a boundary marker.*

Value Defines Form *When value defines form, line is elevated to the level of design element.*

Wet Scraping

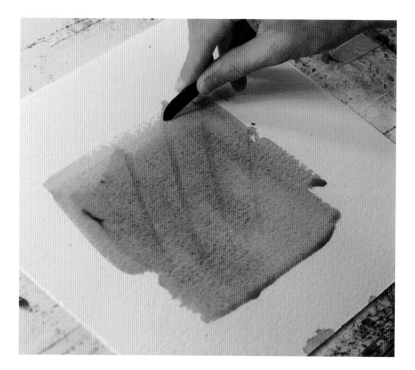

Drawing the chisel end of the brush (or any like tool) across pigment while it is wet leaves a dark line.

Dry Scraping

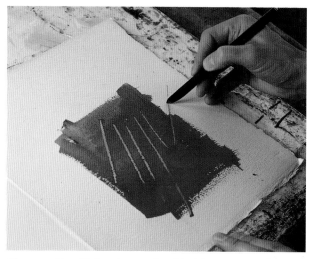

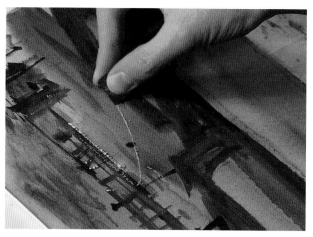

If you wait until the pigment is a bit drier, scraping leaves lighter lines because it pushes the pigment aside.

Scratching Use a razor blade to scratch dry pigment. This is good for accents and embellishments.

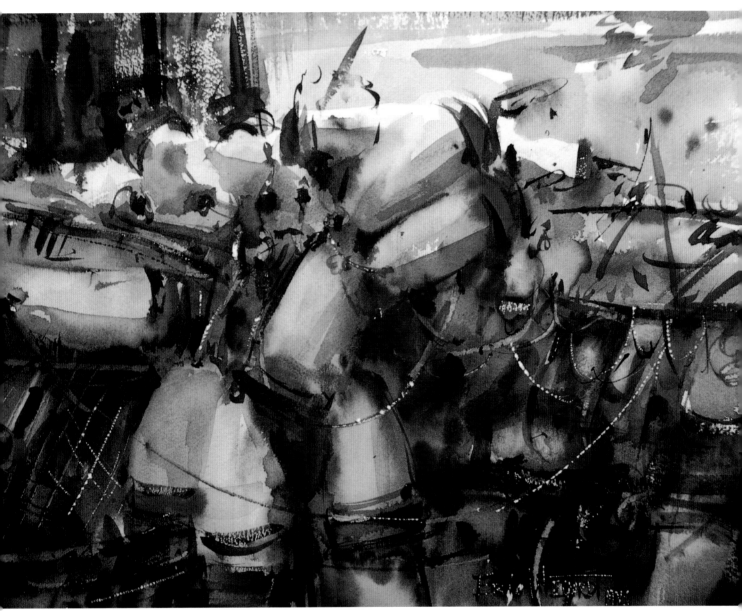

This painting has a large variety of textures made up of wet and dry brush strokes, calligraphic strokes, a variety of edges and scraped and painted lines.

Untitled
Watercolor sketch
Eric Wiegardt

POINTS TO REMEMBER

1. Consider the dimension that beautiful edge quality can add to your painting.
2. Experience dynamic edge quality by working with transitional degrees of wetness on your paper.
3. Use line as an element of design, not a boundary marker. Use value differentiation to show the separation between shapes.
4. A slightly "false" but fresh statement is superior to an overworked, literally "true" one.

Painting Calligraphic Texture
DEMONSTRATION — Eric Wiegardt

The term *calligraphy*, as used here, refers to line work used in drawing or painting.

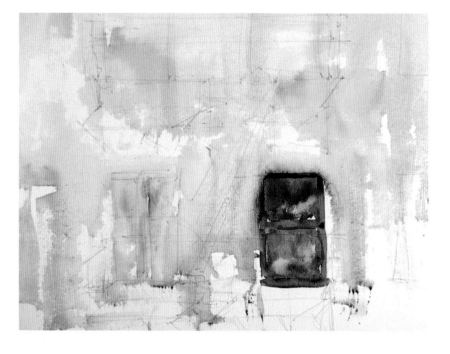

Step One
Create Interesting Edges

After loosely sketching the subject, the artist dropped in some dark color for the window, letting it dry so there was no glare (the wash will be just damp). Then he washed warm color over the face of the building, which creates a beautiful edge as it touches the damp window.

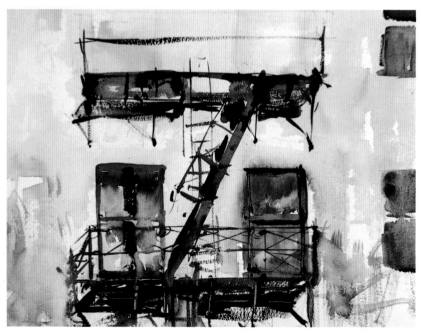

Step Two
Apply Lines Over Shapes

The artist blocked in shapes as the paper dried to the transitional damp stage, then laid down some line work or calligraphy representing the ironwork of the fire escape. Note the variety of edges caused by the transitional damp paper.

Basic Techniques for Painting Textures in Watercolor

Step Three
Continue the Thought

The upper window masses are blocked in, and he scumbled additional washes in the lower part of the wall for texture. This scumbling texture was achieved with a relatively dry brush so the bristles would splay apart and the pigment would skip on the surface of the paper.

Step Four
Apply Additional Calligraphy

Most of the line work is found in the lower part of the painting, in the area of dominance. Here line work is an integral element of the design, not a boundary marker.

Fire Escapes—Astoria
Eric Wiegardt

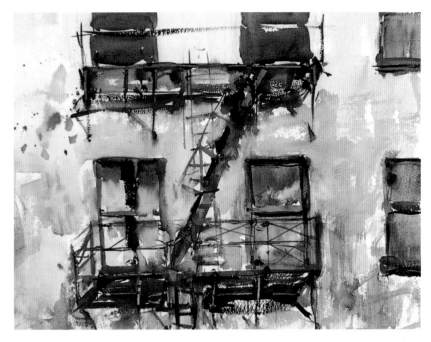

Hard edge **Calligraphy**

Soft edge **Scrape done with the end of a brush handle** **Broken stroke**

Create Unusual Edges With Masking Tape

DEMONSTRATION — Carol Surface

Step One

Surface begins most of her abstract images by pouring paint onto the paper. Here she prepared the paper by brushing clean water onto the paper, skipping a few spots across the center. Next she squirted alcohol across the center of the paper. Then she poured Permanent Rose, Winsor Green and Rowney's Violet Alizarin and tilted the board, letting the colors interact with the water, alcohol and each other.

Step Two

She created the starlike shape by attaching masking tape and painting dark blue inside the tape. The masking tape holds the shape but allows paint to leak for a more interesting edge than does masking fluid.

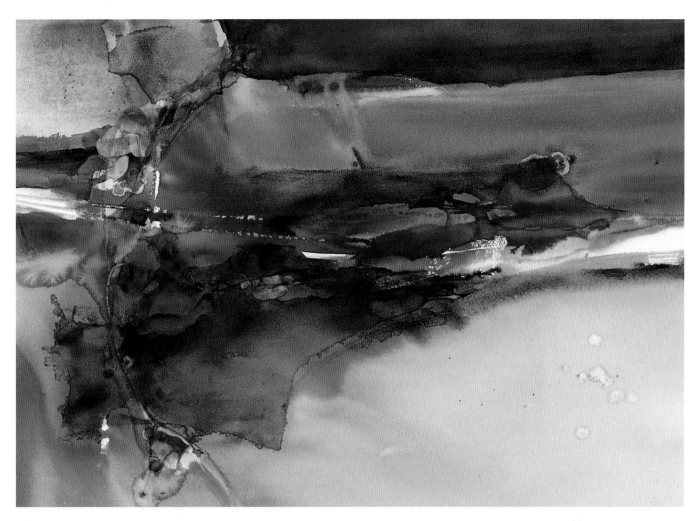

Step Three—Finish

She balanced the composition by intensifying some of the dark shapes in the upper section of the painting.

Spirit Shift
22" × 30" (55.9cm × 76.2cm)
Carol Surface

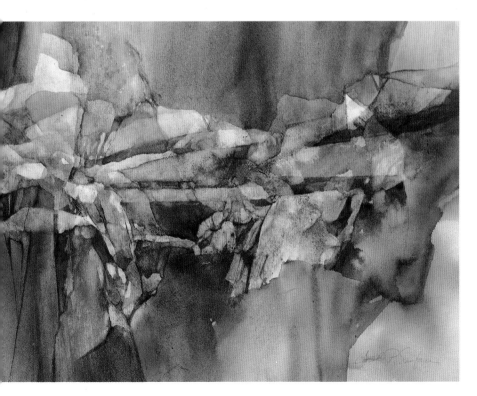

Masking Tape Texture *Another example of how masking tape can be used to create texture.*

Sentimental Journey
15" × 22" (38.1cm × 55.9cm)
Carol Surface
Collection of Ms. Terylann Knee

Textures for Nature Subjects

In chapter two you saw how each of the four main types of brushes are capable of creating a wide variety of lines and textures. But brushes are really only a starting point. The following illustrations will give you some additional ideas for using your brushes as well as other materials to create a wide variety of interesting and creative textures that you can use for nature subjects.

These textural experiments are a means to explore and invent interesting combinations of colors, values and textures by using additives, lifts, resists, spatter, scraping and stippling (to name only a few of the possibilities). When approaching creative exercises like this, try to maintain an inquisitive and even playful attitude. Keep the swatches completely nonobjective and concentrate only on creating an interesting rectangle of texture and color. The purpose of these exercises is simply to expand your understanding and knowledge of various techniques that could be used during the painting process. Sooner or later, bits and pieces from these exercises will manage to work their way into your paintings, helping you to find a more creative or effective way of communicating one of the myriad textures or surfaces found in nature.

Textural Experiments *Experiment with textures to have a "vocabulary" to use to represent the myriad visual and tactile textures found in nature.*

Wet-into-wet/rock salt/Cadmium Orange and Burnt Sienna

Wet-into-wet/rock salt/Cobalt Blue, Alizarin Crimson and Mineral Violet

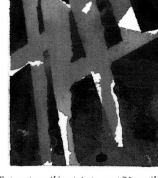

Tape stencil/wet-into-wet/Vermilion, Alizarin Crimson, Burnt Sienna

Wet-into-wet/rock salt/Alizarin Crimson and Payne's Gray

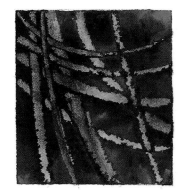

Lifting with brush handle/Vermilion, Alizarin Crimson and Payne's Gray

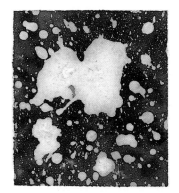

Brush spatter with liquid masking fluid/ Cerulean Blue and Ultramarine

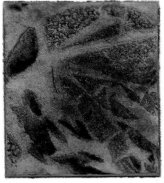

Plastic wrap/Prussian Blue and Payne's Gray

Dry-brush/Mineral Violet/stippling

Water Drops onto damp mixture/Mineral Violet and Cadmium Orange

Plastic wrap/Alizarin Crimson and Payne's Gray

Wet-into-wet/table salt/Alizarin Crimson

Lift method/Mineral Violet and Prussian Blue/cotton swabs

Wet-into-wet/coarse kosher salt/Cerulean Blue and Alizarin Crimson

Wet-into-wet/Viridian, Prussian Blue and Burnt Sienna

Wet-into-wet and spatter/Cadmium Yellow Pale and Cadmium Orange

Wet-into-wet/rock salt/Hooker's Green and Prussian Blue

Toothbrush spatter on dry color/Burnt Sienna and Cobalt Blue

Spatter using masking fluid/Vermilion, Alizarin Crimson and Payne's Gray

Texture Is Shorthand for Reality

On the whole, the function of texture is to focus, simplify, clarify and provide visual order to the objects in a landscape. In realist landscapes, textures are often kept somewhat subtle so as not to detract from the overall illusion of reality. At the same time, "area" textures are used throughout an image to suggest the illusion of reality as in tree bark, foliage or moving water. In areas of flat tone, subtle textural modulations often provide variety, visual interest and a more naturalistic appearance. On the whole, texture is a kind of shorthand language for "reality."

Your objective when using texture is probably not to faithfully and absolutely describe every twig, crack and grain of sand. Instead, you use texture as a way of communicating your own experience of a thing and your own emotional response to it. In other words, you use texture to communicate the essential spirit of each object in a landscape in the most economical and direct visual terms possible.

Foliage Texture *Believable foliage texture can be created with patterns of darks and lights applied wet-into-wet. Texture can also be applied in a more direct and controlled way using "brush calligraphy."*

Rock Texture *A combination of spatter technique, lift method, and controlled, direct use of calligraphy capture the illusion of rock textures.*

Rock Texture *This detail illustrates rock textures created using wet-into-wet texture—i.e., the surface is wet when spatter and direct calligraphy are applied to various areas on the rock.*

Gravel Texture *The gravel was corrected by spatter, applied calligraphy, and the lifting out of light areas that represent the various colors of the pebbles.*

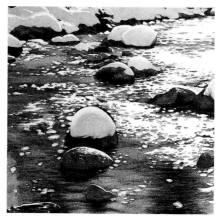

Water Texture *The light conveys direction and surface planes. Some highlights/textures on the water's surface were reserved using liquid masking fluid.*

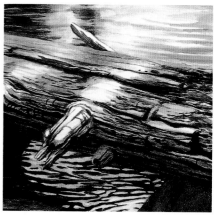

Wood Texture *The artist "weathered" the fallen fir tree with various textures to suggest cracks in the wood, battered bark, and holes reflecting a season's wear and tear.*

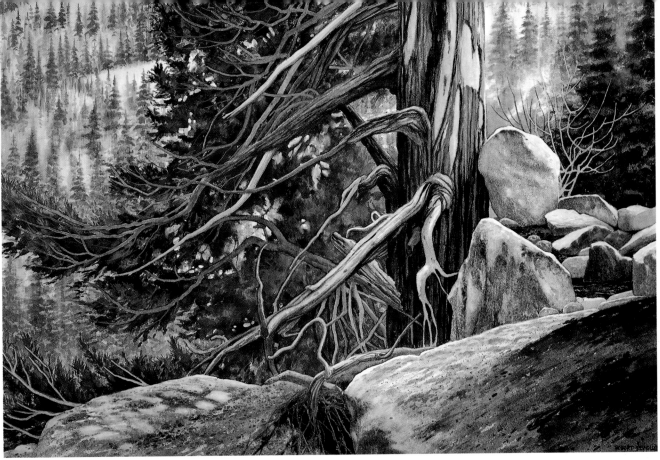

Sierra Juniper
25" × 39" (63.5cm × 99.1cm)
Robert Reynolds
Collection of Bill Todd

Distant Trees *This detail shows the texture used to convey the illusion of distant trees located on the slope of the snow-covered mountain in the background. Brushstrokes were diminished in value, color intensity and detail.*

Tree Bark *When painting tree bark, it's natural to think in terms of creating an authentic texture, but it's equally important to think in terms of creating a strong design when breaking up the forms. Variety can be enhanced by changes of color, value and detail.*

Foreground Elements *Foreground elements like these should normally be rendered in sharper textural detail than elements that appear farther back in the illusion of space or depth. Textures that are more sharply defined always tend to bring the area involved forward visually.*

Simple Trees Through the Seasons

Trees don't look the same all year long—not even if you forget about bare winter trees. In the spring, foliage is lacy, open and much paler in color. In summer, it is dense and has many shades of green, and in the fall, colors blaze. Explore these differences and the variety of textural possibilities they allow.

TIP

Remember when you're painting bare winter trees that the twigs are smaller than the branches, the branches smaller than the limbs, and the limbs smaller than the trunk. Use smaller and smaller brushes to paint them, or a progressively lighter touch. Dry-brush works well for tiny twigs.

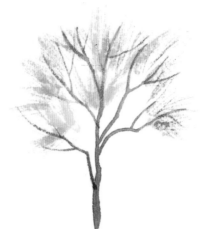

Winter *The winter tree is monochromatic with dry-brush "twigs."*

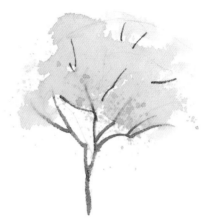

Spring *Open, lacy and light-colored, this spring tree rendering makes use of spatter to hint at the emerging growth.*

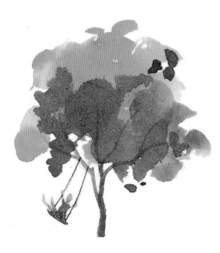

Summer *The twigs are hidden behind the rich color and thick leaves of the summer tree.*

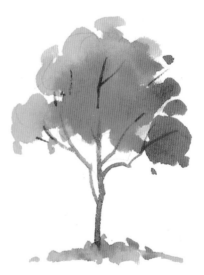

Fall *Notice the use of yellows, golds, reds and browns. The twigs are showing again, having lost their leaves to the changing season.*

Basic Techniques for Painting Textures in Watercolor

Three Simple Ways to Paint Foliage

These exercises work as well for shrubs and bushes as they do for trees, of course. Try using a lacy dry-brush technique over a blob-shaped wash to suggest foliage, or jab with the tip of your barbered fan brush.

Try plastic wrap laid into a wet wash to suggest tree leaves, but don't leave it in place too long in this case; it can become very obvious.

Plastic wrap can be used for more than just tree leaves. Try it for rocky tex-tures or weathered surfaces.

Allow it to remain for only a few moments for a softer effect, or overnight for something much more emphatic. Roll it up into a ball and stamp with it, if you like.

Dry-brush

Wet-Into-Dry *Paint directly wet-into-dry with a round brush.*

Wet-Into-Wet *Once dry, add leaves, twigs and other detail.*

Variegated Underwash and a Wadded Plastic Wrap *First paint a variegated underwash. Cover the area with a wadded plastic wrap for three to five minutes. Remove the plastic wrap and then add leaves and other detail.*

Smooth Tree Bark

Here are some opportunities to use your palette knife, but for this technique to work properly, don't paint your color too wet. The wash must be tacky and barely moist as you apply it. The knifing must take place immediately, particularly for the fine texture. If the color is too wet, it will stain the paper by the time it dries enough to be in a workable condition, and it will look messy. If you knife the color while it's too wet, the knife stroke will actually go dark because the wet paint will creep back into the knifed area. Do it right the first time—apply your color with very little water.

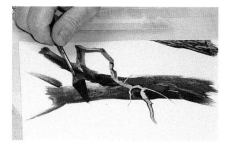

To achieve the bark texture, scrape off the damp color, holding the palette knife firmly by the handle. The thumb transfers the necessary pressure from the wrist. The scraping edge of the knife is held at a 35-degree angle and pressed a little harder at the widest part, creating the lightest lifted value. As you lift the blade toward its point, the gradually reduced pressure results in the bark texture as the value changes.

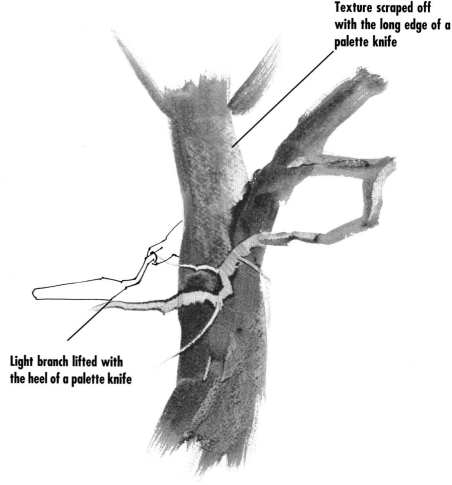

Texture scraped off with the long edge of a palette knife

Light branch lifted with the heel of a palette knife

Start this study by painting the shape of the tree trunk with a 1½-inch (38mm) slant bristle brush filled with a rich consistency of Winsor & Newton Sepia. As soon as you put your brush down, lift out the texture with your palette knife. Hold it pointing to the left, with the edge of the knife pressing hard at the wide part (heel) and releasing the pressure toward the tip. Move the knife downward and the texture is the result. While the color is still wet, paint the limbs. Where the curving branch bends in front of the trunk, extend the shape by knifing out the light branch, pressing hard on the heel of the knife.

Basic Techniques for Painting Textures in Watercolor

Rough Tree Bark

To create this texture, the base color must feel tacky, not too wet. The knife doesn't need to be pressed too hard if the consistency of your color is right. If the wash is too wet, the knife strokes will go dark as the watery wash gushes back into them. Be confident when you press the knife's heel, though great pressure is not required. Remember you are painting sharp light shapes into a damp color. The condition of your wash must be just right.

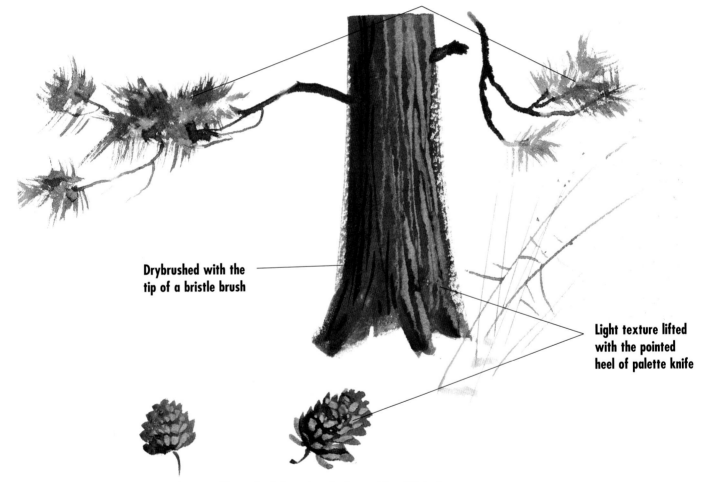

Drybrushed with the tip of a bristle brush

Drybrushed with the tip of a bristle brush

Light texture lifted with the pointed heel of palette knife

Start this rough bark texture with a quickly applied shape brushed on with a 1½-inch (38mm) slant bristle brush, using Burnt Sienna and Phthalo Blue. While the color is still fresh, knife off the light texture by stroking back and forth with the heel of the palette knife. Move the knife up and down, tilting the blade back and forth as if you were sharpening a straight razor on a leather strap.

The technique is similar for the pinecones, but use short, repetitive strokes for the light shapes.

Drybrush the foliage clusters with the tip of a slant bristle brush in the direction the needles grow.

Glazed Tree Bark

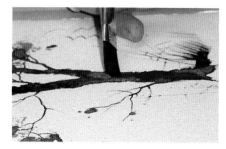

For the relatively small shape of this tree, apply the charging colors with a ¾-inch (19mm) flat, soft aquarelle brush. Use the corner of the brush with gentle pressure to drop the pure colors into the wet shape of the tree. Timing is crucial. Act while the first wash is still very wet.

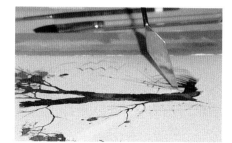

For the delicate weeds, hold the palette knife upright and cut a line into the paper, pressing the tip and releasing a small amount of wet color into the groove simultaneously. The high angle is important to allow gravity to help in freeing the wet color.

H ere, the neutral tree trunk shape is painted with semicomplementary colors that make it less monotonous. The colors charge the gray wash and add a colorful influence. For this approach to be truly effective, the wet-into-wet technique must be used.

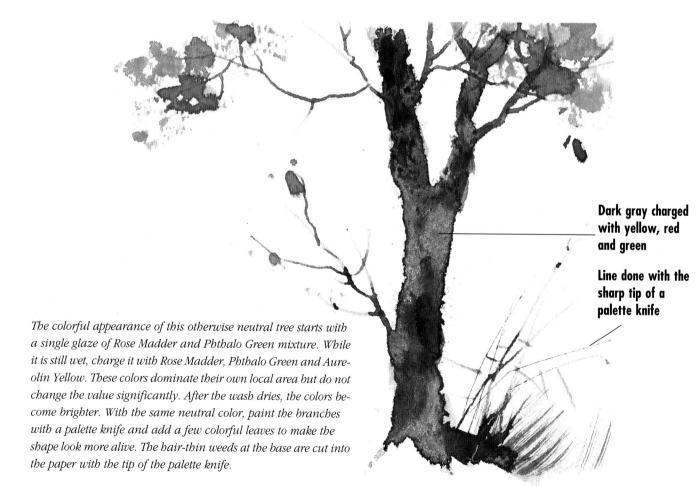

Dark gray charged with yellow, red and green

Line done with the sharp tip of a palette knife

The colorful appearance of this otherwise neutral tree starts with a single glaze of Rose Madder and Phthalo Green mixture. While it is still wet, charge it with Rose Madder, Phthalo Green and Aureolin Yellow. These colors dominate their own local area but do not change the value significantly. After the wash dries, the colors become brighter. With the same neutral color, paint the branches with a palette knife and add a few colorful leaves to make the shape look more alive. The hair-thin weeds at the base are cut into the paper with the tip of the palette knife.

Tree Impressions

With the same brushstroke you can make very different tree impressions depending on whether the paper is wet or dry. The clear-water approach requires dark, wet colors and very careful timing to hit the paint just as it loses its shine. On dry paper, apply your brushstrokes with very light pressure. The weight of the brush is almost enough. On a wet medium- to dark-value wash, tree impressions can be made by brushing the damp paper with a small flat bristle brush or by scraping with a brush handle.

Strokes painted with slanted bristle brush on wet surface

Clear water applied into damp color

Strokes painted with slanted bristle brush on dry paper surface

Clear Water *Using Cyanine Blue and Winsor & Newton Sepia, paint a hint of a forestlike setting on wet paper with a 2-inch (51mm) slant bristle brush. The brush should not be too wet, so it will soak up water and deposit the colors simultaneously.*

Wet Wash *Just after the drying color loses its shine, brush in the shape of the light tree fast enough to keep the spreading light shape from running out of control. At the dark section of the background, remove the light tree shapes with the tip of a slanted plastic brush handle.*

Dry Paper *On dry paper, hold the 2-inch (51mm) slant bristle brush flat so that the handle is parallel with the paper and the narrow end is at the top of the evergreen. The edge of the hair lines up with the potential location of the tree trunk. As you touch the paper, half of the evergreen shape emerges. To do the other half, flip the brush to its other side and repeat the stroke.*

Rock Island With Trees

A very important part of this technique is to charge the otherwise dark base wash with pure staining colors. These will stain the paper, and after you knife out the shapes of the rocks, they will show these dominant hues in lighter value, making them sparkle with color. Staining colors are the key here.

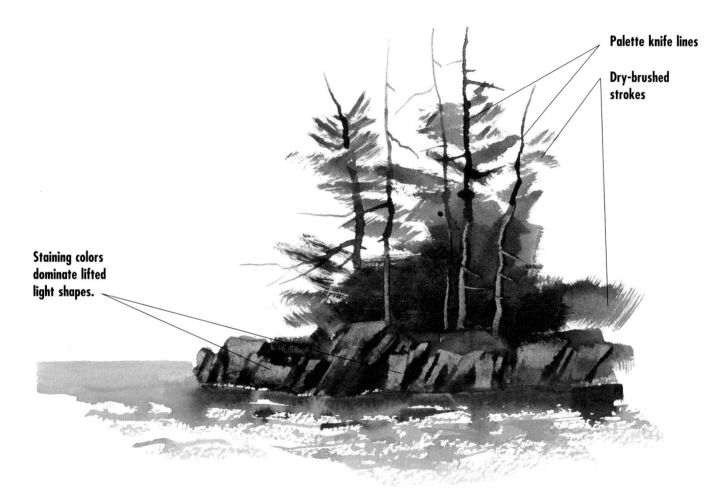

Palette knife lines

Dry-brushed strokes

Staining colors dominate lifted light shapes.

Paint the foliage of the pine clump using Rose Madder, Burnt Sienna, Cyanine Blue and Phthalo Green in varied dominance. From this very dark, wet shape, knife out the light tree trunks and branches. Then paint the dark part of the tree trunks with a small rigger. To paint the rocky foreground, add dark colors strongly dominated by individual hues at different areas. With the firm heel of a palette knife, squeeze off the slablike shapes of the rocks. The color dominance will become even more evident in these lighter shapes. Glaze the water, drybrushing the lower edge to hint of sparkling waves.

Palette Knife Trees

You must use very liquid paint for this technique. The paint must flow off the knife the same way it flows out of a brush. When you paint the branches, hold the knife lightly and drag it with a light pressure against its tip, without lifting it, until it runs out of paint.

This technique also can be used for exciting abstract background texture, particularly if you crisscross your shapes or apply different colors for different strokes. Don't limit this or any other technique to only one subject. Expand on it by using your imagination.

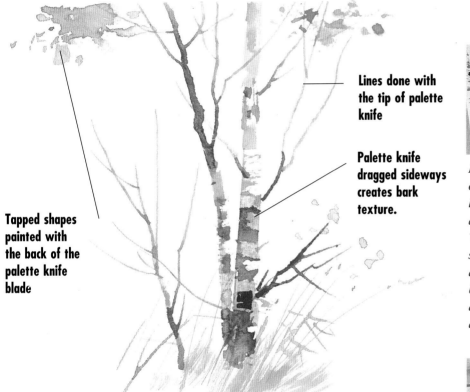

Lines done with the tip of palette knife

Palette knife dragged sideways creates bark texture.

Tapped shapes painted with the back of the palette knife blade

For the loose birch bark effect, dip the palette knife in wet color and, holding it at a low angle, touch the edge on the dry paper and make a horizontal dragging stroke. Where the color comes off as a solid wet shape, knife off the light sections immediately with the firmly pressed heel of the blade. The knife's response is unpredictable; be prepared to add or remove color as required.

Using Cyanine Blue, Rose Madder and Aureolin Yellow, paint these trees entirely with a palette knife. For the trunk, use a little liquid paint on the knife's edge and touch it to the paper, dragging it from one side of the trunk to the other. Where the color is textured, leave it alone. Where it is too solid, knife out a lighter strip. Repeat this, varying the colors a little. With a dark liquid mix on the palette knife, paint the branches and the young sapling. Tap on a few leaves with the back of the knife point. Tapping means to touch the paper repeatedly with the back of the knife blade to which the liquid paint was applied. Cut the delicate, tall weeds into the paper with the edge of the knife tip covered with a little liquid paint. The small dry-brushed grass cluster at the tree's base is the only part done with a brush.

The position and angle of the palette knife is important as you paint the branches. The liquid paint rushes off the blade if it is held on a very high angle, while its flow slows down if the blade is held flatter. Drag the knife's tip away from the trunk to allow the branches to taper toward their point.

Rough Grasses and Weeds

To achieve texture, try scraping through a wet wash, then through one that has begun to lose its shine. *Scraping* is quite versatile; you can make light or dark lines—thick or thin—or scrape out fairly broad areas. You'll find a dozen ways to use this handy technique.

Rough Grasses

Put down a good, strong wash, and while it's still wet, scratch through it with the end of your brush, a craft knife or your fingernail. The paper's fibers will be bruised, and you'll get a darker line where you've scraped.

Or, let the shine disappear somewhat and scrape with your tool held at an acute angle to the paper while your wash is still damp; some of the pigment will be moved out of the way, leaving a lighter area. Do this for light-struck limbs or grasses.

Let a wash dry completely and scratch through it with a sharp craft or pocket knife for some really sparkling linear effects. These *are* pure white, unlike those scraped lines, and they're nice for the glitter of sun on water, dew on a spider's web—use your imagination.

Take a closer look at your subject; unless they're on a manicured lawn, most grasses are interestingly mixed with tall and short, blade and broadleaf. There's a variation in color as well.

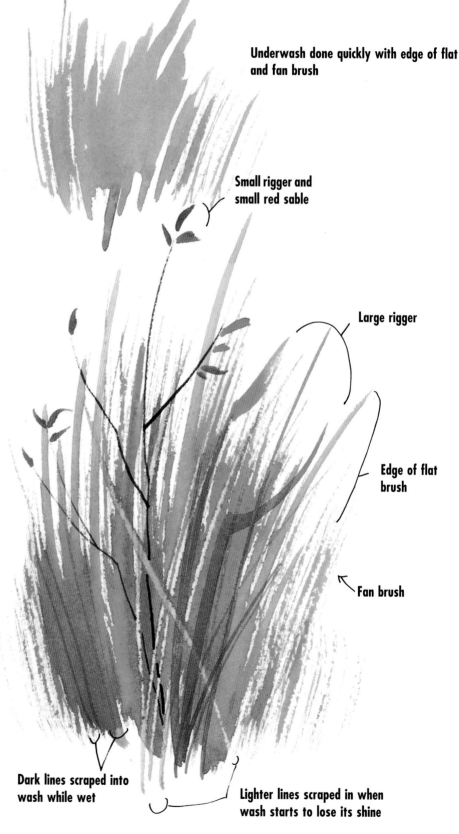

Underwash done quickly with edge of flat and fan brush

Small rigger and small red sable

Large rigger

Edge of flat brush

Fan brush

Dark lines scraped into wash while wet

Lighter lines scraped in when wash starts to lose its shine

Basic Techniques for Painting Textures in Watercolor

Weeds

1. Make a wet-into-wet shape for local color. Local color is the color an object actually is, without taking variations of light and shade into consideration; it is a middle tone.

2. As it dries, scrape in light lines as you did with your rough grasses.

3. Now, add the details as you see them. Let yourself go—do as much or as little as you like.

Notice the variety of shapes and textures.

Jagged Granite Rocks

Here's another chance to use your palette knife to describe shapes. But remember: Your knife must be held firmly by its handle while your wrist delivers the necessary heavy pressure. Never hold the blade with your fingers; they aren't strong enough to squeeze off the colors. Use the widest and firmest part of the blade (the heel) because that is where the metal is firm enough to do the job.

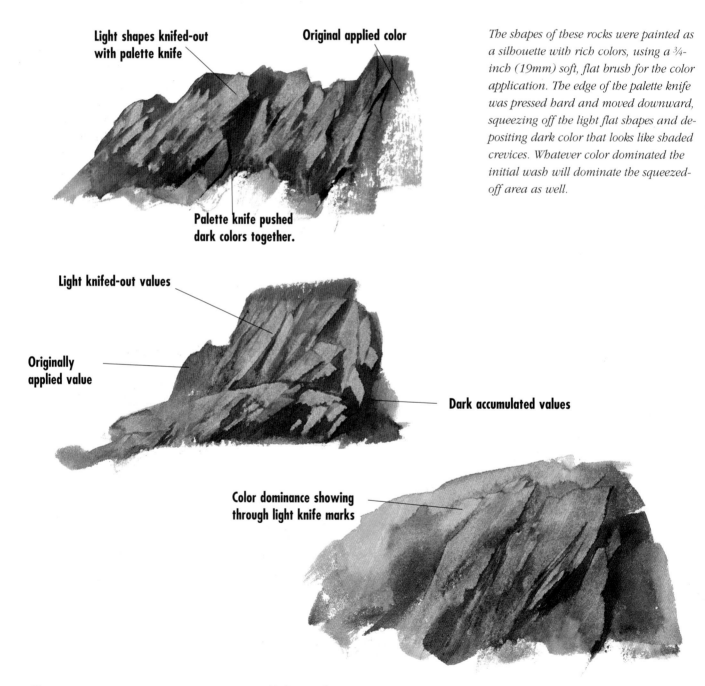

Light shapes knifed-out with palette knife

Original applied color

Palette knife pushed dark colors together.

The shapes of these rocks were painted as a silhouette with rich colors, using a ¾-inch (19mm) soft, flat brush for the color application. The edge of the palette knife was pressed hard and moved downward, squeezing off the light flat shapes and depositing dark color that looks like shaded crevices. Whatever color dominated the initial wash will dominate the squeezed-off area as well.

Light knifed-out values

Originally applied value

Dark accumulated values

Color dominance showing through light knife marks

Rounded Glacial Rocks

These rounded rock shapes are similar to the jagged rocks, but the movement of the palette knife is different. For best results use paint with a thick, creamy consistency for these shapes. Holding the knife by the heel and the tip pointing down, press hard at the heel and gently lift toward the tip while lifting off the color. This tilt will produce the textured transition from the lightest to the darkest value. If your color is too runny, the wet pigment may gush back to the path of the knife.

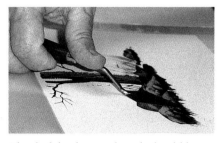

The dark background wash should be a tacky consistency. Then knife off the light values on the rocks with the wide, firm, pointed heel of a palette knife. Grip the handle of the knife with your fingers and apply the pressure with your thumb. Don't use your fingers on the blade for pressure. The thumb must carry the pressure from the wrist to the handle for best results.

High-pressed lift area

Low-pressed limited lift area

Accumulated color area

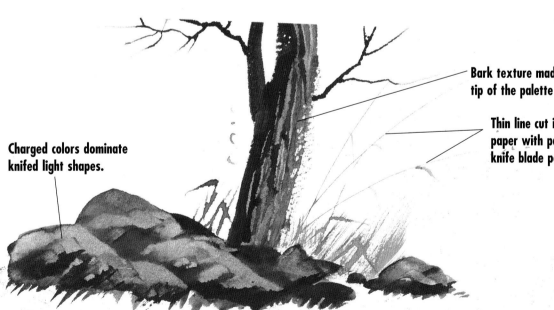

Bark texture made from tip of the palette knife

Thin line cut into dry paper with palette knife blade point

Charged colors dominate knifed light shapes.

These rounded rocks were all painted with a ¾-inch (19mm) soft, flat brush and textured with the heel of a palette knife. Use complementary colors to establish their natural color shape and value. The colors above are Ultramarine Blue, Rose Madder, Gold Ochre, Burnt Sienna and Winsor & Newton Sepia. Do not scrape wet color off but squeeze it off with the firm heel of your knife.

Painting Mountains With Salt, Spray and Opaque Washes

D E M O N S T R A T I O N — Sharon Hults

Sharon Hults loves to paint mountains—the majesty of their form, the delicacy of their foliage, the subtlety of their atmosphere. Over the years she has developed watercolor techniques to capture these disparate qualities of mountains.

Softening Edges With a Spray of Water

One of the most important tools in Hults's studio is a spray bottle of water. In order to have maximum control of color placement, she drybrushes about three-fourths of her image. That can give too stiff and technical a look to natural scenes, so when the paint has dried, Hults sprays areas of it with water, letting the sprayed water soften the edges and surface of the dried paint.

For foliage areas she often sprays water onto the dry paper with a coarse spray, creating droplets of water with dry paper in between. Then she paints the foliage. Where the paper is dry, the paint forms precise, hard edges. Where the paint runs into droplets of water, it softens.

Another technique for foliage is to spatter color onto the paper with a toothbrush. Then she sprays the edges that she wants softened or more irregular. She can also pull the wet edges with a brush to get a more pleasing shape.

Sprinkling Salt for Subtle Texture

For texture in mountains and foliage she sprinkles salt into a layer of paint. She says, "Your paper needs to have a slight shine from the paint, but you want no puddles standing. The humidity in your studio also affects how the salt works."

For a more subtle texture she repeats the process with several layers of paint and salt, letting each one dry in between.

If it begins to look like too much of the texture is showing in the painting, she will glaze over some of it with a wash and no salt.

Layering With Opaque Glazes

To create atmosphere in her mountains, she often glazes over them with Permanent White Designers' Gouache. She explains, "I often paint my mountains a stronger color than I want because I always glaze over them with at least one opaque layer. You can create several different mountain ranges by adding more layers of the white glaze for greater distance. If you use too much, you can scrub it off like transparent watercolor.

"Sometimes I spray, salt or blot lightly to give an irregular effect. It needs to go on looking like it's almost going to blot out the image, because it dries much lighter."

Photos *Hults begins by assembling photographs for the composition of her painting.*

Basic Techniques for Painting Textures in Watercolor

Step One

Hults carefully draws the image in pencil on 140-pound (300g/m²) cold-pressed Arches paper. She masks out the areas that will remain lightest.

She paints with the paper flat and un-mounted so she can easily switch back and forth between several paintings. Working on more than one at a time, she is able to let each layer of color dry for two or three days, setting the color and making it impervious to lifting.

Step Two

She glazes over most of the large shapes. As she finishes each area, she salts it lightly.

Step Three

While the colors in the mountain peak are drying, she lightly sprays it with water and adds color to the shadowed areas. Again she salts lightly. By continuously spraying and salting she builds up an interesting surface texture. It is very obvious in the first stages but gets more subtle as she adds more layers.

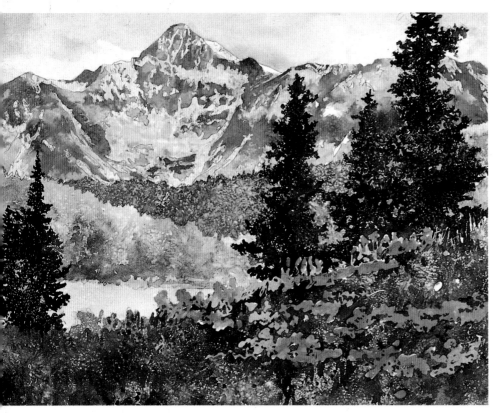

Step Four

The irregular effect of the color in trees and grass is achieved by spraying loosely with water. Then she adds color, letting it flow into the puddles of water. Additional texture is created with salt and by spattering with a toothbrush onto the grass area. The mask is removed and flowers are added.

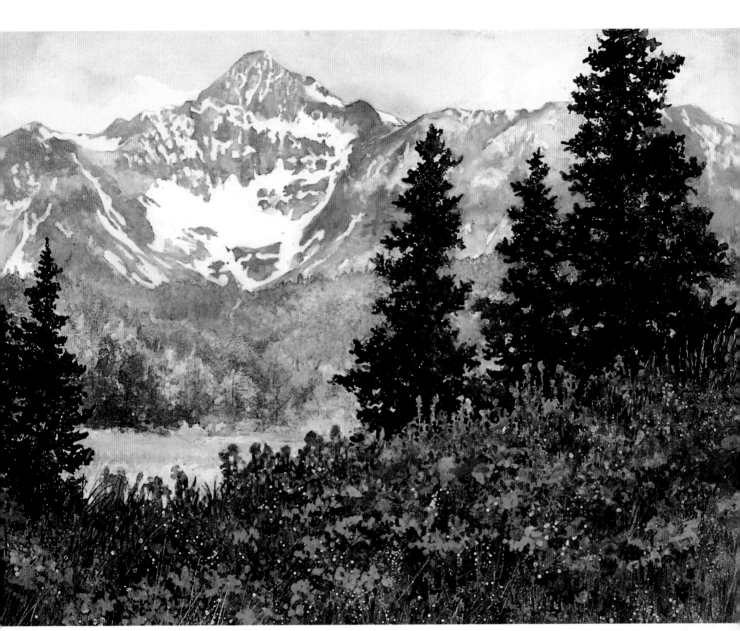

Wilson Peak
22" × 30" (55.9cm × 76.2cm)
Sharon Hults

Step Five

Final colors are added and enhanced. Then after everything has dried, a thin glaze of white gouache is added over the mountain and distant hillside. More flowers are spattered into the foreground and opaque grasses are laid in for a finishing touch.

Putting It Together

How does she keep the techniques from overwhelming the image? She plans her composition carefully. She combines slides and photos to get exactly the image she wants and then draws that carefully onto the watercolor paper. The sketch is important for establishing realistic perspective of all the elements (a tree in one photo may be bigger than a mountain in another) and keeping consistency in the highlights and shadows.

As she continues to add color and texture with her various techniques, she keeps looking at the image as a whole. She might love the effect of a particular technique, but if it doesn't contribute to the success of the total painting, she scrubs it out or paints over it.

Texture Techniques for Nineteen Other Subjects
Shiny Things

Step One

Use a pencil to make a preliminary "map" of shiny highlights.

Step Two

Add wet-into-wet washes, painting around or masking highlights.

Wet-into-wet

Wet-into-wet

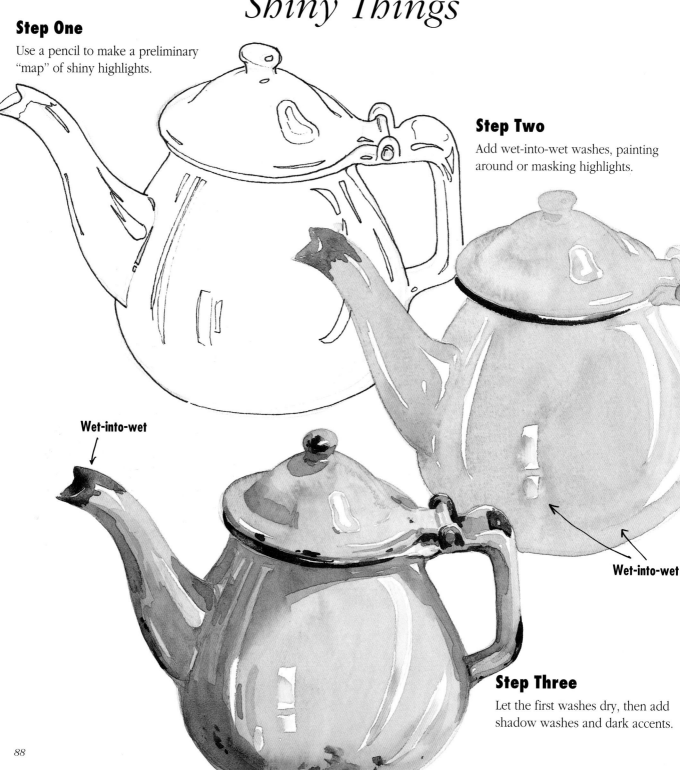

Step Three

Let the first washes dry, then add shadow washes and dark accents.

Onto *dry* wash

Dull Things

Step One

Draw your shape and lay in preliminary wash. Wet-into-wet adds interest.

Step Two

While this wash is wet, lay in the shadows.

Leave edge for definition, if you like.

Step Three

Let everything dry thoroughly, then add details to define shape.

Bright Metal

Antique shops always house an array of items that make for interesting compositions. For this painting, the artist eliminated a number of objects from in front of the shop window. He felt this corner would be more interesting if the eye were allowed to move to the inside of the shop. The focus is on the quilt, but with interesting things everywhere, your eye will browse as you would in an antique shop.

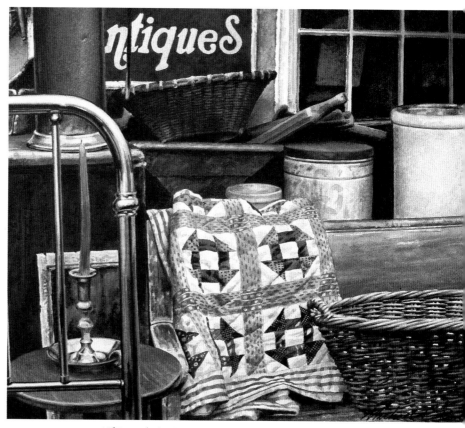

Skippack Antiques
10" × 13" (25.4cm × 33cm)
Michael P. Rocco

Detail of Brass Bed *Notice the reflection of the quilt from the surface of the headboard. Consider how the other objects in your composition impact the bright metal ones.*

Step One

The secret in painting bright metal is to capture the smooth, sleek surface. Brushstrokes should emulate these qualities with evenly applied paint. First draw the image lightly on the watercolor sheet, then correct it using a T-square and triangle to ensure straight and parallel lines. Paint a pale wash of Naples Yellow on all the metal and let this dry. Add other values of colors to give shading and initial form to the rails and connectors as well as the candlestick. Straight lines can be painted with the aid of a guide for your hand and brush. The colors on the edges of the rails are reflections from other objects in the composition. Paint in the background for value relationships and to contour the metal.

Step Two

Further develop the tubular shapes of the brass bed by blending intermediate tones of the shadow on the top rail and adding others to the verticals and connectors. Due to the curve of the top, the dark tones have an intermittent effect. Handle the brass candlestick in the same manner, painting colors and values that reflect its form.

Basic Techniques for Painting Textures in Watercolor

Step Three

Tone down the reflected color under the top rail, and gradually blend deeper tones into the shadow until you gain its effect. You can follow the same procedure for all the rails. Do not change the reflected color. Notice how the extreme dark painted along the side of reflected color accents the light and gives shape to the rails—how it makes the metal glisten. Paint the forms of all the connectors, accenting their shape and highlights with darks. On the bottom rail, the dark line is in from the edge, allowing the reflected light to add to the form. Finish the candlestick, developing its form and shapes with color and shadows, then add accents of darks for effect.

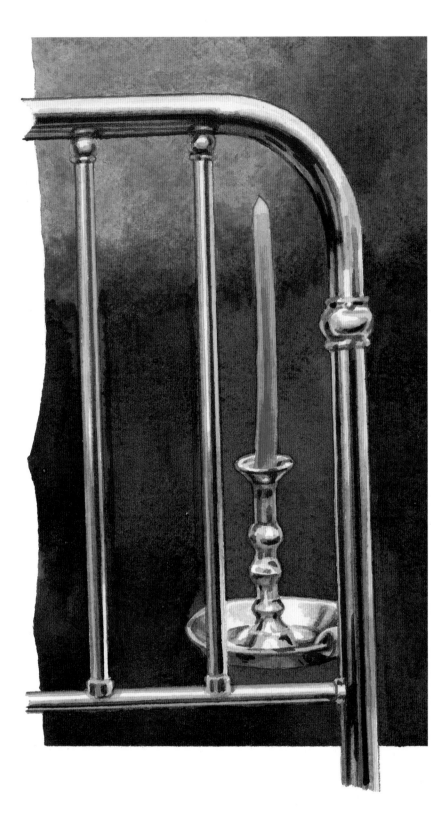

Old Metal

Coming upon a deserted barn brings all kinds of thoughts to mind about the people that were once here. What made them leave? From the appearance of the barn, it looked like it had not been in use for some time.

Barnyard
23″ × 17″ (58.4cm × 43.2cm)
Michael P. Rocco

Detail of Old Metal Tub *Old metal objects show signs of decay like the discoloration and buckling bottom edge of this tub.*

Step One

To obtain uniformity of value and color, paint the entire tub with a wash of pale color. Once dry, blend in a slightly deeper value, leaving sections of the first wash exposed. In this way, form the rim, handle and support ridges, and at the same time, indicate the character of the metal. With a third tone, start forming its shape.

Step Two

Shadow the inner left side and blend soft shading to the opposite side to further enhance its curve. Under the ridges, add subtle tones for a gradual change of values. There are no distinct shadows from these ridges in the sunlit area. Drybrush more texture into the metal, deepen the shadow of the outside wall, and accent the bottom ridges. Except for its various tones, the galvanized metal is monochromatic, and the coloring should reflect this.

Step Three

Paint in the discolorations on the metal. Deepen the shadow on the inner wall, but hold its quality of reflected light. As this shadow nears the upper rim, strengthen its darkness; this intensifies the feeling of light and also accents the form. Blend additional color into and deepen the shadow of the outside wall. Detail the handle and add its dramatic shadow, which gives the feeling of space between the handle and tub wall. Deepen color under the ridges to accentuate them as well as the shadows of the bottom ridges. Finish by putting in the rivets and seam lines.

Rusted Metal

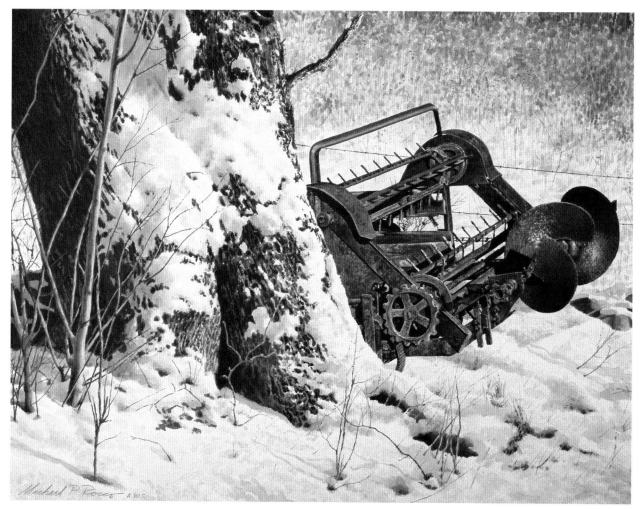

Farm Relic
16" × 21" (40.6cm × 53.3cm)
Michael P. Rocco

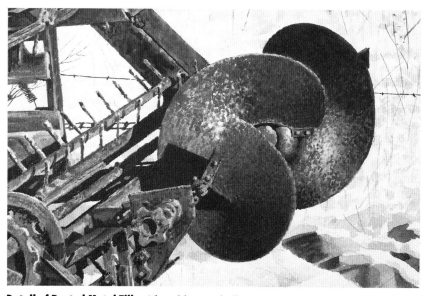

Detail of Rusted Metal Tiller *This old, rusted tiller is an interesting contrast in texture next to the snow-covered tree.*

This is a painting achieved from different transparencies. The artist wanted to paint the handsome snow-covered tree trunk but felt it needed something more to tell a story and be of greater interest. Fortunately some distance away in the field, he found the discarded tiller. Its gracefully formed blades, worn and encrusted, were full of appealing earthy colors. The tiller made a good foil against the snow and tree.

Basic Techniques for Painting Textures in Watercolor

Step One

To gain the look and texture of rust, paint patches of light color throughout, noting bends and planes of metal angles, cylindrical rods and curvature of the blades. Follow this with intermediate colors to further structure the various shapes and begin the texture. Paint the dark brown of the uppermost blade to establish a space relation with the middle blade. Put in the strong shadows to help clarify the mechanism and attain brilliance.

Step Two

Start painting the texture of the crusted metal by overlaying colors and working into the original areas. Use the point of a no. 4 round brush to spot in colors in a methodical pattern. On the foreground metal plate, put in the light on its edge that sets it apart from the shadow of the blades. Note the number of colors used here. Generally one thinks of rust as reddish brown, but it takes on a variety of colors depending on the light.

Step Three

Continue to texture the metal in the same manner, bringing values down and developing the beautiful contours of the blades. Be careful not to lose the sparkle of sunlight on the metal. Finish the chain gear in a similar manner, putting in highlights on edges, shaping with intermediate color and accenting with shadows for depth. Don't overlook details such as rivets and prongs. Specks of dark color pronounce their appearance.

Old Brick

Sicilian Kitten
14" × 21" (35.6cm × 53.3cm)
Michael P. Rocco

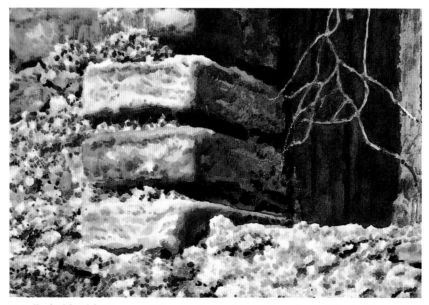

Detail of Old Brick *The crumbling mortar and uneven surfaces of the bricks create a nice contrast in texture to the soft, young feline.*

It is rather odd to travel all the way to a foreign country and come home to paint a watercolor of a wary feline, but you never know when or where a composition will come about. The kitten lingered long enough for the artist to photograph it. The crude outbuilding is on a farm and houses a beehive oven and a place to stomp wine grapes.

Basic Techniques for Painting Textures in Watercolor

Step One

Paint the mortar with a wash of warm pale gray, working around the brick. Put in the varied light colors of the bricks, allowing each color to dry before painting another, to achieve hard edges. With second tones, add light shadows to the sunlit face of the brick and mortar. Establish contrasts using darks in various colors and values on the shadow sides of the brick.

Step Two

With intermediate tones and color variations, add texture to the mortar, developing its shadows. Due to reflected light, these shadows differ in value from those under the brick, and this relationship helps give the feeling of depth. Further develop the irregular surface of the brick with deeper tones. Paint the red brick at the top to assist the feeling of light.

Step Three

Accent the texture of the mortar with darks using a dry brush. Scrape away some of its color for sparkle, underlining these spots with specks of dark. Treat the face of the brick in the same manner, deepening washes, adding texture and accenting its aged look. Strengthen shadows under the brick and the darks of the corners to add dimension and reflected light.

Barn Siding

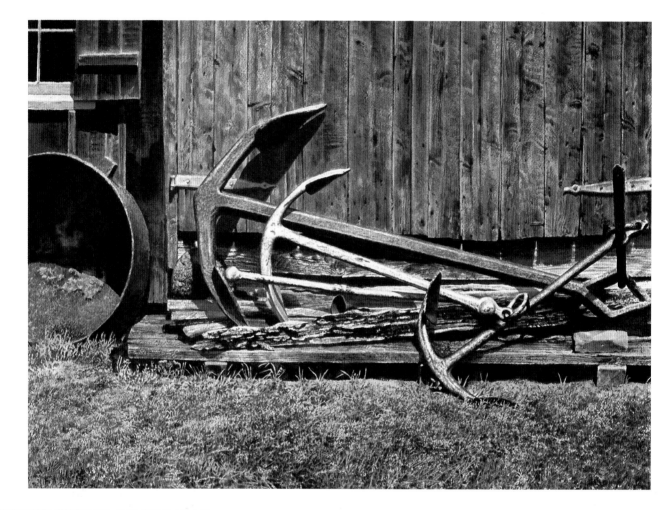

Detail of Barn Siding *The rough texture of the wood is somewhat softened by the proximity of the hard metal anchors.*

Notice the number of huge anchors in such an unlikely place—the side of an old barn. But looking at it as a potential painting, the artist was impressed by the varied textures and the strong contrasts. Look at the shadow cast by the anchor onto the side of the barn. Notice its value and the amount of light it's receiving, how it stays on the wall and helps the anchor to project from it. A small but vital detail.

Old Anchors
17" × 23" (43.2cm × 58.4cm)
Michael P. Rocco

Basic Techniques for Painting Textures in Watercolor

Step One

Using a flat 1-inch (25mm) brush, paint the entire side of the barn with the lightest color of the wood. Brushstrokes should be vertical, same as the siding. Once this dries, add color variations, keeping in mind where each board begins and ends. Use the broad side of a no. 8 pointed brush, dragging it on the paper for texture. The light color on the edges of the boards implies thickness.

Step Two

Paint more color variations of the wood using the same brush technique along with some dry-brush for additional texture. Light shadow lines define the boards.

Step Three

Add final color variations and wood grain. Diagonal brushstrokes simulate saw marks. Clean off some color with water before putting in the dark holes that butt the top of the cleaned area. The roughness of the wood is accented by pinpoints of dark color. Deepen shadow lines in varying degrees.

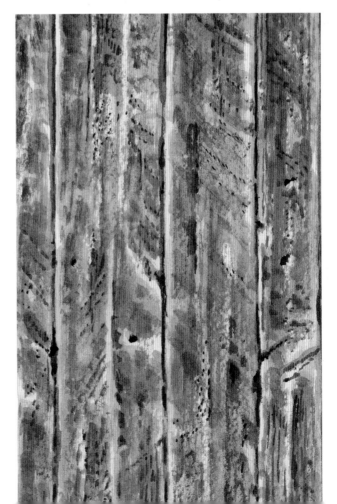

Sunlight on Wood

Y ou must use a well-sized, high-quality paper for this technique. Noblesse, Arches, Lanaquarelle, Waterford are all papers that will work. For best results the staining color used for the wood-grain texture must be the first color to touch the paper. The less staining the shadow color is, the easier it is to remove it. Test the colors you intend to use, on scrap paper, before diving into a complex painting.

Shadow color as it dried on top of wood-grain texture

Slightly stained color left from Burnt Sienna in the shadow color

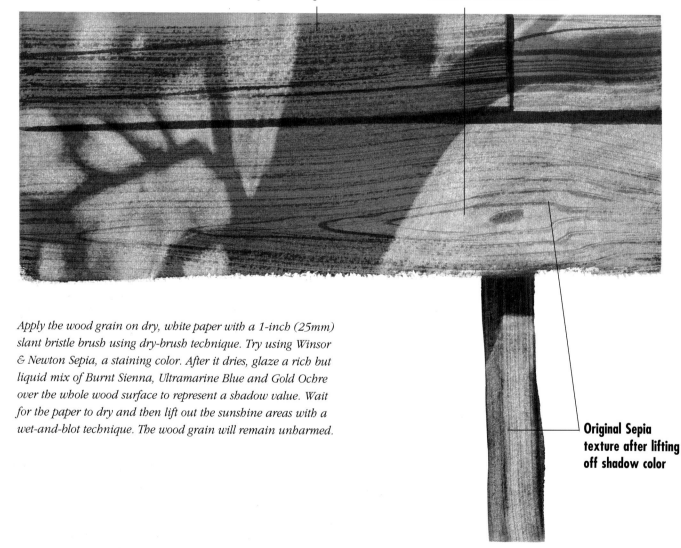

Apply the wood grain on dry, white paper with a 1-inch (25mm) slant bristle brush using dry-brush technique. Try using Winsor & Newton Sepia, a staining color. After it dries, glaze a rich but liquid mix of Burnt Sienna, Ultramarine Blue and Gold Ochre over the whole wood surface to represent a shadow value. Wait for the paper to dry and then lift out the sunshine areas with a wet-and-blot technique. The wood grain will remain unharmed.

Original Sepia texture after lifting off shadow color

Basic Techniques for Painting Textures in Watercolor

Cobweb

This technique works best with a dark background. The moody interior of an old barn or an ancient castle is just the place for a romantic touch such as this. The dark suface shows off the beading, dusty appearance of the cobweb. Be sure your background wash is bone dry. You may want to blow-dry it with a hair dryer for about twenty-five seconds to make sure that any humidity that might have entered the paper from the air is completely removed.

For this effect the paper has to be bone dry. Hold the sharp tip of a small pocketknife blade firmly between the thumb and fingers at a 90-degree angle. Pressing very hard, scrape out the beaded lines with several lightning-fast strokes. It is important to use an extremely sharp blade.

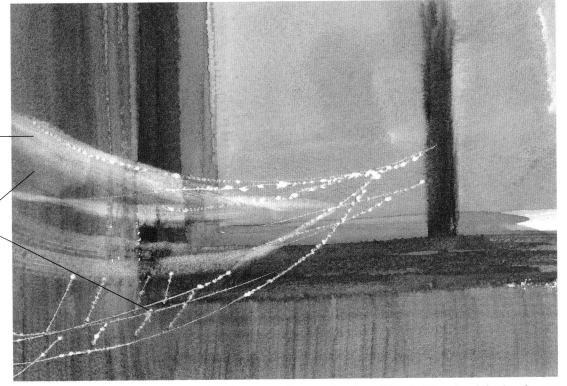

A wet brush was used to scrub out the dusty, soft web.

Dark background shows the web better.

These lines were scraped out with the sharp tip of a pocketknife.

First paint in the window frame as well as the gray wall next to it using a ¾-inch (19mm) soft flat brush. Keep these washes on the darkish side with Burnt Sienna and Ultramarine Blue. Follow with the outdoor sky color, Cobalt Blue, with a little Aureolin Yellow near the bottom. After everything is dry, scrape out the thin lines of the web with the very sharp point of a pocketknife. Hold the knife on a very high angle. This way it gets caught in a few places making the impression of a beaded line. Link several of these lines together to make it look convincing. To make the web a little older and dustier looking, wet and quickly wipe off some of the color for the soft light shapes complementing the white lines.

Dark Glass

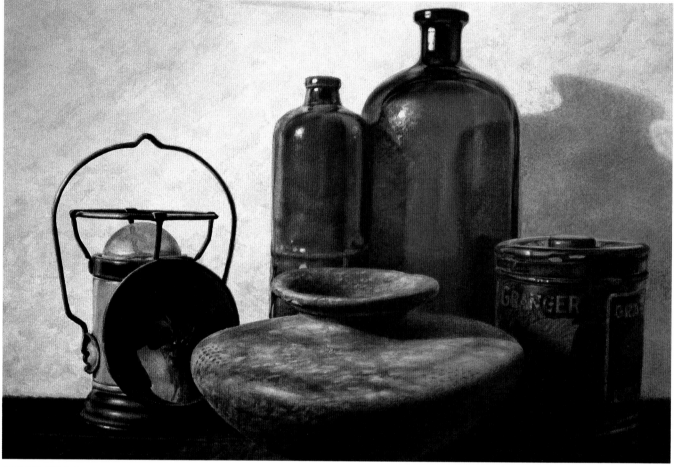

Still Life With Lamp
11" × 17" (27.9cm × 43.2cm)
Michael P. Rocco

The thing to remember in painting glass is that most of it has an extremely smooth surface, and your color washes should reflect this. Equally important is to obtain the transparency or translucency of the object. In this painting, the light passing through the glass, producing a warm glow within the shadow, helps to project that feeling.

Detail of Dark Glass Jug *The shadow that can be seen through the jug on the right amplifies the feeling of transparency.*

Basic Techniques for Painting Textures in Watercolor

Step One

Start by painting the color along the edges and the glare of light on the body of the jug. Once that dries, paint an overall even base color, leaving the extreme highlights on the flange and neck. This base color is determined by the secondary highlights on the body of the flask. Allow this wash to dry.

Step Two

Apply another wash to deepen color, leaving some of the base color showing on the right portion of the jug. Soften the edges with clean water, and blend carefully for smoothness. Add deep color on the flange, neck and top of the body to start feeling its form, and add the shadow on the left.

Step Three

With a small pointed brush, "noodle" the form of the jug using very short strokes. Add deeper accents to obtain the roundness of the shape. Paint the base, paying attention to its inner contour and cleaning off some color for highlights. To give the glass transparency, clean off some more areas of paint with water and brush.

Glazed Crockery

Jug and Stained Glass
12" × 19" (20.5cm × 48.3cm)
Michael P. Rocco

The wood building, stained glass, old wooden bench and glazed jug produce a simple and direct composition made more interesting by the variety of textures.

Detail of Glazed Crockery *The ridges and valleys depicted here are vital to a realistic earthenware texture.*

Basic Techniques for Painting Textures in Watercolor

Step One

Besides form, the important thing to capture in earthenware is the glaze generally found on the surface. Begin by painting various tints of color, working these in a wet blend on dry paper. Keep the color flowing and fresh so no area dries, but leave the highlights clean. Once dry, put in the dark background to give the feeling of light on the jug. Add a second tone under the lip, and clean away some color from the jug's bottom, giving a highlight to that ridge.

Step Two

Blend washes of color to develop the form and glaze of the body. Wash away more color to form ridges and valleys, accenting these with light shadow. Paint some shadows on the right, staying in from the edge, which has reflected light to give the jug its cylindrical feel. Add tones to the lip, turning it under, and put in the shadow on the neck.

Step Three

With the point of a no. 2 brush, blend in colors, feeling the form as you render. Work the dark shadow with gradually deeper tones of varied color, for it too contains a great deal of reflected light. To get indistinct edges, first paint it in a pale blue, then add deeper blue to the center of all the lines. Finish by adding the chipped notches and shadow line on the bottom.

Textiles

Mask out stitches and
paint later with ochre.

Lay the preliminary damp surface wash on
heavy, and blot with a crumpled tissue for
a stonewashed look. Use a mix of Burnt
Umber and Ultramarine Blue.

Worn Denim

Texture the denim with Payne's Gray or
India ink using wavy line pen work.

Deepen shadows with damp
surface blending techniques and
Payne's Gray paint.

Ribbed Knit

Braided outline

Mask out print design while background
material is painted. Use damp surface
blending techniques and blotted highlights.

Loose
cross-hatching

Cotton Print Fabric

Define the floral print with
dry-brush and pen work.

India ink pen work,
tinted with watercolor

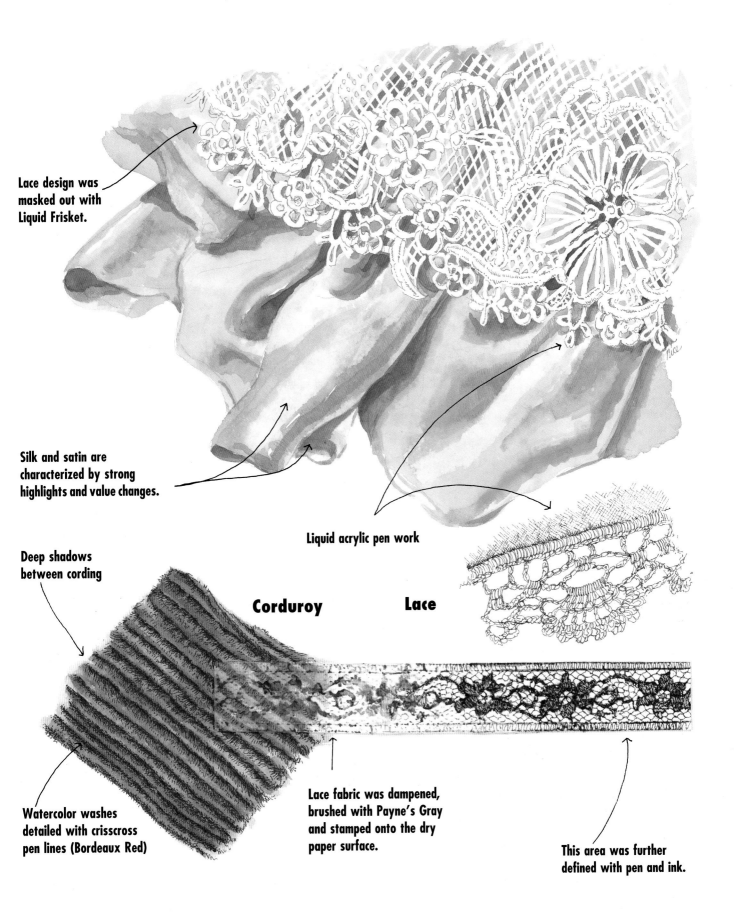

Lace design was masked out with Liquid Frisket.

Silk and satin are characterized by strong highlights and value changes.

Liquid acrylic pen work

Deep shadows between cording

Corduroy

Lace

Watercolor washes detailed with crisscross pen lines (Bordeaux Red)

Lace fabric was dampened, brushed with Payne's Gray and stamped onto the dry paper surface.

This area was further defined with pen and ink.

Draped Cloth

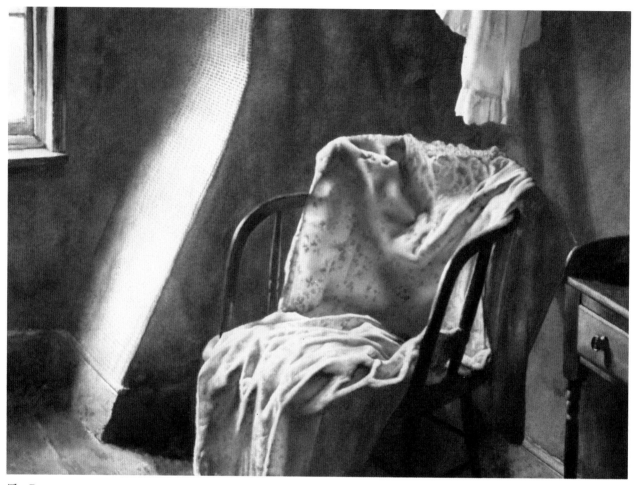

The Dress
17" × 23" (43.2cm × 58.4cm)
Michael P. Rocco

This is a scene from a house in the historic area of Gettysburg, Pennsylvania. The story is told that Jenny Wade was the only civilian killed in that famous battle of the Civil War. She allegedly was making cookies at the time a stray shot came through the wood and mortally wounded her. The soft light from the window filtering into the room with its angled alcove and plain wallpaper, along with the fascinating story, compelled the artist to do the painting.

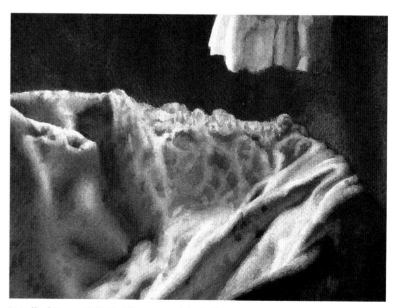

Detail of Draped Cloth *The natural light from the window shows off the sheer, lightweight nature of the dress.*

Basic Techniques for Painting Textures in Watercolor

Step One

After drawing the image, paint a pale blue wash on the dress, and while it is still damp, drop in some color on the ruffle of the neckline. Once this is dry, put in a simple background to establish contrasts. Add a deeper tone of blue, leaving sections of your first wash exposed for highlights on the folds of the materials.

Step Two

Put in a third tone of blue, again leaving areas of the previous washes showing. At this point it resembles a silkscreen print with its flat areas of color and hard edges, but you are establishing the formation of the folds and proper values of shadow. There are so many wrinkles to contend with that it's easier to paint in this method and blend later.

Step Three

Now you can wash and blend. Using clean water, work the harsh edges of darker tones into the lighter color until you gain the soft roll of the folds. Deepen shadows to form definite creases, and with their proper placement, you'll achieve the reflected light on a fold. Add deeper tones to the ruffle, giving it shape, then accent with darks to further the feeling of light. With varying values of color, paint the dot pattern of the cloth but not completely, for in some areas the dots are obliterated by the light.

Rope

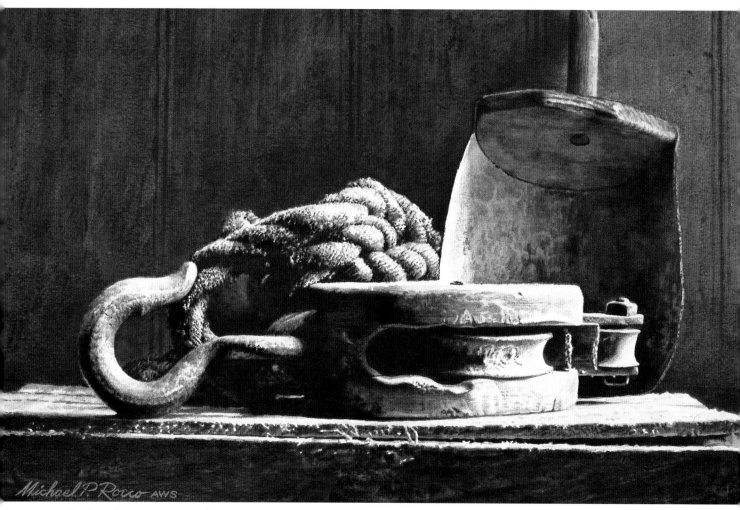

Still Life With Scoop
12"×18" (30.5cm×45.7cm)
Michael P. Rocco

Over the course of the years, you've probably accumulated quite a bit of odds and ends. Use some of the more interesting items to set up still lifes. You can photograph them with intentions of painting them at a later date. If creating these compositions is a complete departure from your other subject matter, it may keep your interest at a high level.

Detail of Rope *Achieving the coarse texture of rope requires using color to create the weave and then washing or scraping away color to highlight the rough fibers.*

Step One

Mix a pale wash consisting of Naples Yellow and Yellow Ochre, and paint the rope, allowing it to dry. Then put in the background for light effect and comparison of future values. For this area, use two brushes, a no. 4 round for outlining and a 1-inch (25mm) flat for filling. Starting at the rope, outline a small section, then fill immediately down to the edge of the paper, keeping the color flowing at all times.

Step Two

Using Raw Umber, paint shading to help clarify and hold the bunched rope as a mass. Add pale washes of Payne's Gray for form and to delineate the spiraled weave of the strand. Paint deeper tones of these colors in some areas for added depth.

Step Three

Now detail the weave using various values of colors. Accent the coarse fibers with specks of dark color. In some areas, where the light is strongest, the weave is lost completely. Strengthen the form of the strands with deeper tones and dark shadows, which also add to the feeling of light. Treat the shadowed area (bottom center) without any detail except for reflected light. This intense dark solidifies the mass and gives light to the background, producing a spatial relationship between the wall and rope. Wash and scrape away color to highlight coarse fibers, then accent weave lines and soften the top contour of the rope.

Wicker

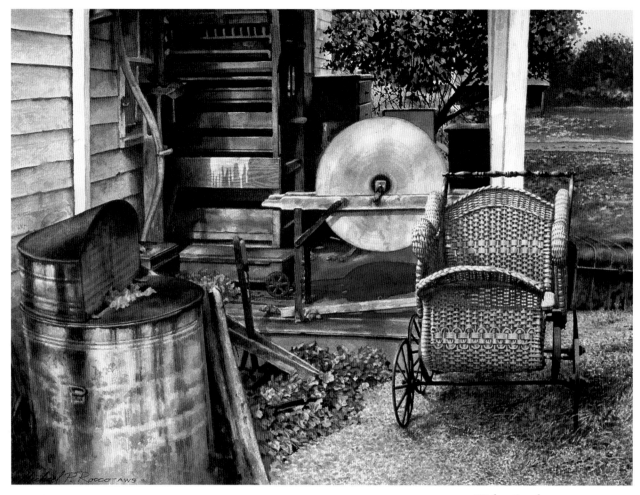

Wicker Coach
17" × 23" (43.2cm × 58.4cm)
Michael P. Rocco

The artist started the painting above by drawing the projected image directly onto the watercolor paper, except for the wicker coach. Here he taped a sheet of tracing paper in position, being careful not to disturb the board, and made a very detailed drawing of the coach. The step-by-step demonstration on the next few pages illustrates how to paint a woven surface.

Detail of Wicker Coach *In painting a subject that is complex and seems to be a confusion of lines, you may want to make a drawing on tracing paper so that you have something to refer to when needed.*

Basic Techniques for Painting Textures in Watercolor

Step One

After tracing the general outline of the coach, paint its lightest color over the entire area. Once the wash is dry, tape your drawing in position and transfer certain sections onto the painting. Now add a second tone, blending where necessary, but leaving areas of your first wash showing. Paint a third tone of deeper value to start establishing form and shadow.

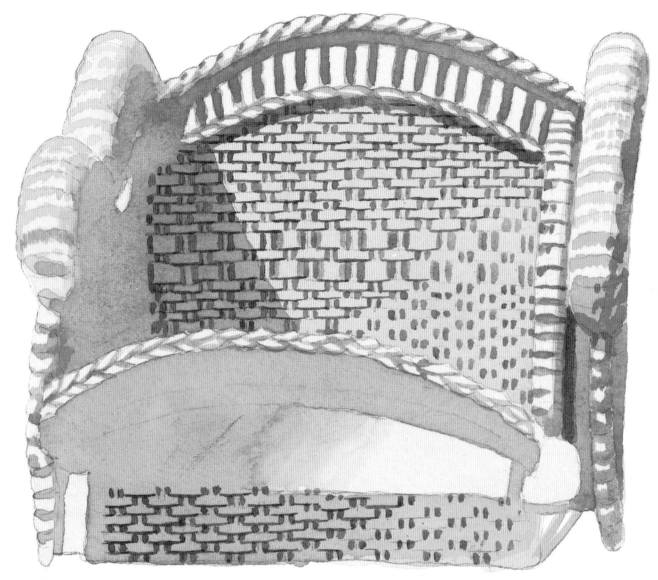

Step Two

Strengthen some shadows and put in the cast shadow on the left as well as the one under the roping. Again, tape your drawing in position and carefully trace the weave onto the painting. You can simplify your painting procedure by putting in all the darks on each side of the vertical reeds, stopping these shadows at the top and bottom of the horizontal weave, thus giving thickness to the reeds and width to the flat strips. Next, line the bottom of all the horizontals. The tops are receiving light and do not get a shadow. Add shading to the rope weave on the back as well as the intertwined weave of the front. Paint light tones on the side tops to create a ripple effect.

Basic Techniques for Painting Textures in Watercolor

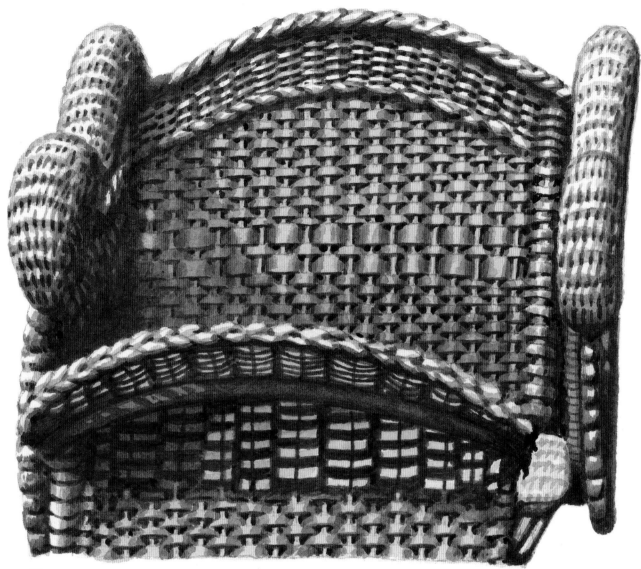

Step Three

Once you complete the pattern, model the in-and-out weave with additional values of color, emphasizing the construction with triangular shadows that also accent the vertical reeds. Due to the curvature of the back, the modeling tones should get slightly deeper toward the bottom. Form the top and curve of both sides, then carefully detail the weave with darks between the reeds. Put in the dark weave of the inner left side, noting its reflected light. Do the same for the front to achieve its see-through effect. Add a few dark accents on the tubular construction, and finally clean away some spots of color, then stop. Don't overwork it.

Old Baskets

Step One

Paint the light color of the windows first and, while these areas are still damp, apply the pale yellows and greens of the outdoor foliage. Next give the entire whitewashed wall a pale color. Using a no. 12 round brush, scrub this wash roughly to simulate the stucco texture. Allow this area to dry.

Paint the light edges of chipped putty and indented wood on the window frames and follow with the darks, keeping a subtle suggestion of reflected light. Establish the planes of the sill and walls, working in more texture to the stucco.

Step Two

Paint the light colors of the baskets first, then with intermediate tones and shading, give the baskets form. Put in tones to explain the weave and delineate splines of the flat basket that projects in front of the large basket. Carefully form the twisted strands of the handle by painting darks around lights. Blend preliminary colors in the upper portion of the handle to establish its round shape. Also indicate the upward curve of the major ribs as they bend around the large basket.

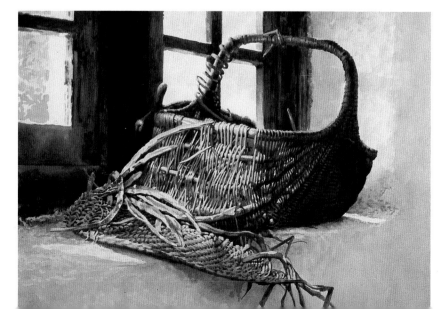

Step Three

Now work on the weave of the baskets. Accentuate bends with color washes, and paint various values of darks between splines. Develop the shape of the individual strands. Several values of shading on the flat basket form the rows of its weave. Wash away some color from individual strands to accentuate the light. Suggest the weave throughout the shadowed side of the large basket.

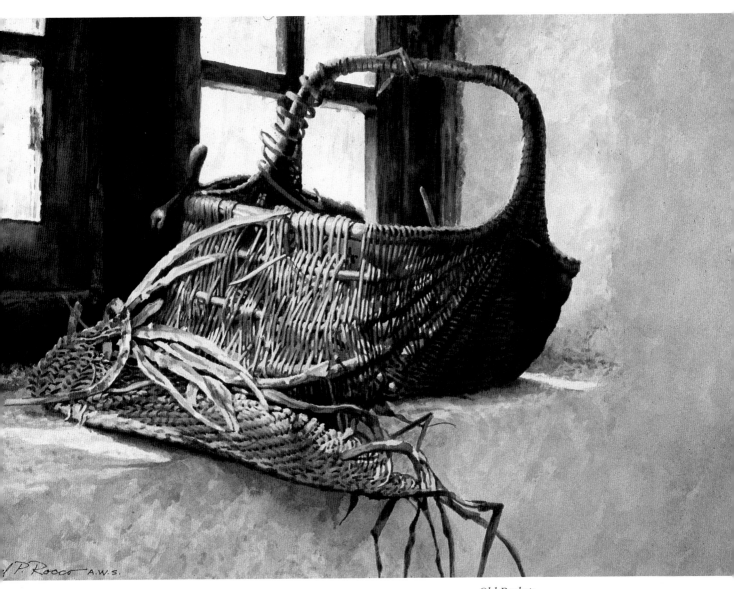

Old Baskets
14" × 21" (35.6cm × 53.3cm)
Michael P. Rocco

Step Four

Add final details to the baskets, washing away specks of color in the shadow area of the large basket for added interest and to assist its hollow feel. Strengthen some darks; this, in turn, intensifies the feeling of light. On the walls, increase the structure of the window alcove with washes of deeper value and by strengthening shadows. More dry-brush for the stucco texture and the painting is complete.

COLORS

- Lemon Yellow
- Yellow Ochre
- Raw Umber
- Olive Green
- Alizarin Crimson
- Cerulean Blue
- Payne's Gray
- Neutral Tint
- Warm Sepia

Native American Basketry

Wicker

Step One
Begin each basket sketch with a detailed pencil study. Basket weaves and materials vary greatly and can be quite complicated.

Step Two
Detail the pencil lines with pen work. Add shadows and texture.

Step Three
Tint with watercolor washes.

Step Four
Use additional washes and dry-brush work to add depth and dimension.

Use brown pen work for warm colored areas.

Use black India ink for cool colored areas.

Makah Native American Basket

This basket was woven from grasses, cedar bark, roots and fern stems.

Note the whale design woven into this rather complex West Coast basket.

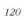

Pottery

Pencil in the design and darken using pen and ink.

Tint bowl with varied washes of Burnt Umber, Burnt Sienna and Yellow Ochre.

Contour lines

Semimatte finishes have a low range of value contrasts, with soft, blended transitions from light to dark.

Hopi clay pot

Bright glass trade beads provide a nice contrast to the earth tones of clay pottery.

Deepen the shadows with Burnt Umber.

Painting Simple Fruit

Step One
Apply wash of local color. Leave a highlight area.

Step Two
Add shadow of complementary color.

Step Three
When dry, add final details. Pick out more highlights with sharp knife.

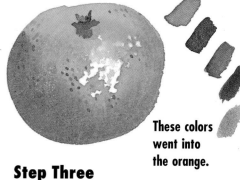

These colors went into the orange.

Step One
For two-color (or more) fruits, lay in one pure color. Leave a highlight.

Step Two
While wet, add secondary colors and shadows.

Step Three
Add details when thoroughly dry.

These colors went into the apple.

Step One
For dull fruits (like bananas, peaches, apricots), there is no need to leave highlights—just lay in wash of local color.

Step Two
Add soft details as first wash loses its shine.

Step Three
When dry, add final details.

These colors went into the banana.

Slightly More Complex Fruit

Mask out seeds—but not all of them.

Step One

Lay in a good, strong wash.

Step Two

This one shows a bit of wet-into-wet shading. You wouldn't remove mask until this dried. Apply a touch of yellow on the seeds.

Step Three

Add final details when dry. Notice that the seeds in the shadow look dark, *not* bright yellow. Also, the seeds are less round as the berry recedes.

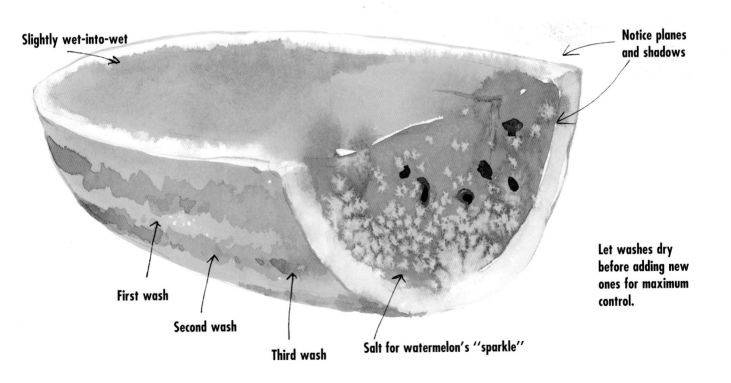

Slightly wet-into-wet

Notice planes and shadows

First wash

Second wash

Third wash

Salt for watermelon's "sparkle"

Let washes dry before adding new ones for maximum control.

More Fruit

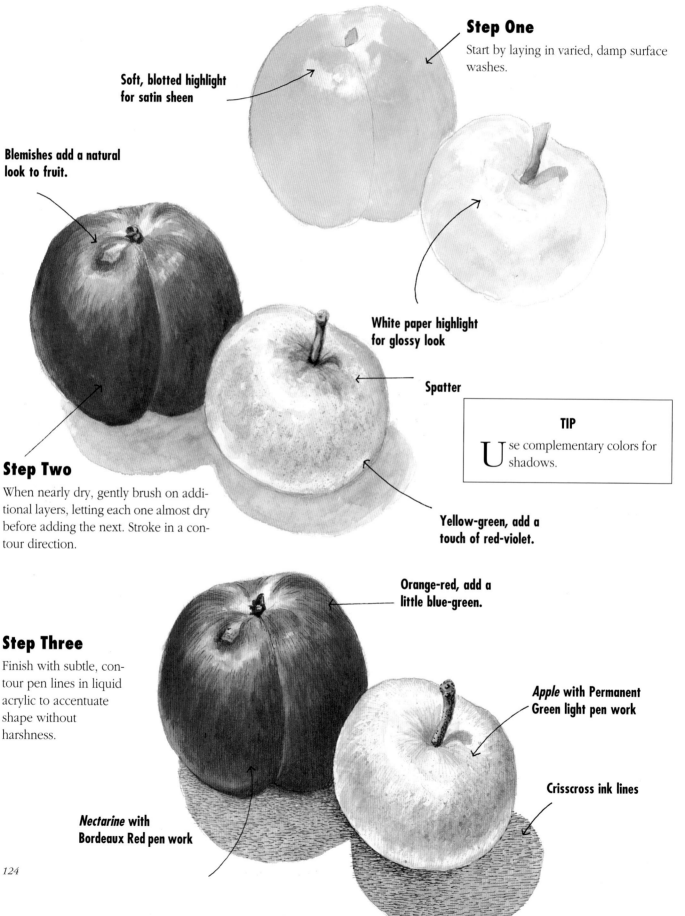

Step One
Start by laying in varied, damp surface washes.

Soft, blotted highlight for satin sheen

White paper highlight for glossy look

Spatter

Blemishes add a natural look to fruit.

Step Two
When nearly dry, gently brush on additional layers, letting each one almost dry before adding the next. Stroke in a contour direction.

Yellow-green, add a touch of red-violet.

Orange-red, add a little blue-green.

Step Three
Finish with subtle, contour pen lines in liquid acrylic to accentuate shape without harshness.

Apple with Permanent Green light pen work

Crisscross ink lines

Nectarine with Bordeaux Red pen work

TIP

U se complementary colors for shadows.

The fruit and berries on this page are layered watercolor washes detailed with pen and ink or liquid acrylic.

Cantaloupe Rind

Step One
First lay down a light tan-gray wash. Let dry.

Step Two
Mask out a veinlike pattern.

Step Three
Paint with an olive green mix. Remove masking.

Step Four
Detail with brown pen work.

Raspberries are semitranslucent with a satin sheen.

Blueberries have a powdery bloom, suggested by blotted layers of paint and India ink.

Blackberries are firm, with a glossy skin.

Mask out highlight pattern.

Brown, stippled pen work adds a dimpled texture to orange peels.

Wet-into-wet

Shadows give definition and placement to the fruit.

INDEX

Abstracts, 50-53
Adobe Abode, 40
Alcohol techniques, 37
Artists
 DeLoyht-Arendt, Mary, 41
 Engel, Charlene, 47
 Hults, Sharon, 5, 87
 Kessler, Michael, 45
 McVicker, Jim, 45
 Miller, Carl Vosburgh, 40
 Reynolds, Robert, 44, 71
 Richards, David P., 48
 Rocco, Michael P., 90, 94, 96, 98,
 100, 104, 106, 110, 112, 114, 119
 Roeder, Edith, 6, 49
 Surface, Carol, 50-53, 67
 Szabo, Zoltan, 2
 Wagner, Judi, 8-9, 40
 Webb, Frank, 48
 Wiegardt, Eric, 43, 45, 55, 59, 63, 65
Artist's hand, 46-47

Bamboo brushes, textures made with,
 23
Bamboo pen, exercises, 30
Barn siding texture, 100-101
Barnyard, 94
Basket textures
 Native American, 120
 old, 118-119
Blotting techniques, 35
Bonnie's Azaleas, 59
Botanical Garden, 47
Brick texture, 98-99
Bright metal subjects, 90-93
Bristle brushes, 16
 exercises, 29
Broken edges, 54
Brushes, 14-16
 bamboo, 23
 bristle, 16, 29
 care, 15
 chisel, 16, 29
 fan, 16, 27
 filbert, 16

flat, 14, 22, 25
hake, 16, 22
liner, 16
mop, 16
rigger, 16, 26
round, 14, 21, 24
script, 16
stencil, 16, 28
travel, 16

Calligraphic texture, 64-65
Chisel brushes, 16
 exercises, 29
Cobwebs, 103
Cold-press paper, 11
Colors, 17
Crockery, glazed, 106-107

Damp surface techniques, 33
DeLoyht-Arendt, Mary, 41
Double Illusion: Across Paris Skies, 48
Draped cloth textures, 110-111
Dress, The, 110
Dry scraping, 62
Dry surface techniques, 32
Dull subjects, 89

Edges, 54-67
 broken, 54
 erased, 54
 expressive, 55
 hard, 54
 scumbled, 54
 soft, 54
 tape, creating with, 66-67
 varied, 54
Engel, Charlene, 47
Erased edges, 54
Erasers, 19
Exercises
 bamboo pen, 30
 bristle brushes, 29
 chisel brushes, 29
 fan brushes, 26
 flat brushes, 25

palette knives, 30
rigger brushes, 26
round brushes, 24
sponges, 31
stencil brushes, 28
towels, paper, 31
Expense, 18
Expressive edges, 55
Expressive gestures, 46-47

Fan brushes, 16
 exercises, 26
Farm Relic, 96
Filbert brushes, 16
Fire Escapes—Astoria, 65
Flat brushes, 14
 exercises, 25
 textures made with, 22
Flat solid brush style, 47
Flooding, 44
Foilage texture, 70, 73
Foreground elements, 71
Free-flowing line brush style, 47
Fruit textures, 122-125

Glacial rocks, 83
Glass, dark, 104-105
Golden Spring, 2
Granite rocks, 82
Grasses, 80-81
Gravel texture, 70

Hair dryer, 19
Hake brushes, 16
 textures made with, 22
Hard edges, 54
Hatchmark brush style, 47
Hopper, The, 45
Hot-press paper, 11
Hults, Sharon, 87

Impasto style, 49
Impressed textures, 36
Introduction, 8

Jug and Stained Glass, 106

Kessler, Michael, 45

Larry, 43
Life Journeys, 53
Liner brushes, 16
Lines, 54-67
 values and, 61

Mahoning Valley Road, 49
Marina, 40
Masking compound, 19
Materials
 bamboo pen, 30
 brushes, 14-16. *See also* Brushes
 erasers, 19
 expense, 18
 hair dryer, 19
 masking compound, 19
 paints, 17
 palette, 18
 palette knives, 30
 paper, 10-13. *See also* Paper
 paper towels, 19
 pencils, 19
 sponges, 19, 31
 spray bottle, 19
 supports, painting, 18
 surface, painting, 18
 tape, 19
 towels, paper, 31
 water containers, 19
McVicker, Jim, 45
Metal subjects
 bright, 90-93
 old, 94-95
 rusted, 96-97
Miller, Carl Vosburgh, 40
Mop brushes, 16
Mountains, 84-87

Native American basket textures, 120
Nature subjects, 68-87

Old Anchors, 100
Old Baskets, 119

Old basket textures, 118-119
Old metal subjects, 94-95
Opaque washes, 84-87
Open weave style, 47

Paintings
 Adobe Abode, 40
 Barnyard, 94
 Bonnie's Azaleas, 59
 Botanical Garden, 47
 Double Illusion: Across Paris Skies,
 48
 Dress, The, 110
 Farm Relic, 96
 Fire Escapes—Astoria, 65
 Golden Spring, 2
 Hopper, The, 45
 Jug and Stained Glass, 106
 Larry, 43
 Life Journeys, 53
 Mahoning Valley Road, 49
 Marina, 40
 Old Anchors, 100
 Old Baskets, 119
 Private Dancer, 53
 Red and White Rhodies, 46
 Sentimental Journey, 67
 Shackford Place, The, 8-9
 Sicilian Kitten, 98
 Sierra Juniper, 71
 Sierra Penstemon, 44
 Skippack Antiques, 90
 Spirit Shift, 67
 Still Life With Lamp, 104
 Still Life With Scoop, 112
 Thaw on Lizard Creek, 6
 Todd and Lezlie's Wedding Flowers,
 55
 Untitled, 46, 63
 Volcano, 48
 White House Roses, 41
 Wicker Coach, 114
 Wilson Peak, 87
 Wind Weaver, 42
 Winter Fog, 5

Paints, 17
Palette, 18
Palette knives
 exercises, 30
 trees, creating, 79
Paper, 10-13
 cold-press, 11
 hot-press, 11
 rough, 11
 sizing, 12
 stretching, 13
 weights, 12
 wetness of, effect on texture, 56
Paper towels, 19
Pencils, 19
Personal texture, 48
Pointillism brush style, 47
Pottery textures, 121
Private Dancer, 53

Raindrops, texture through, 45
Red and White Rhodies, 46
Reynolds, Robert, 44
Richards, David P., 48
Rigger brushes, 16
 exercises, 26
Rocco, Michael P., 90, 94, 96, 98, 100,
 104, 106, 110, 112, 114, 119
Rock texture, 70, 78, 82-83
Roeder, Edith, 49
Rope textures, 112-113
Rough paper, 11
Round brushes, 14
 exercises, 24
 textures made with, 21
Runs, 40-44
Rusted metal subjects, 96-97

Salt techniques, 37, 84-87
Scraping, 62
Scratching, 62
Script brushes, 16
Scumbling, 20
 edges, 54
Sentimental Journey, 67

Shackford Place, The, 8-9
Shiny subjects, 88
Sicilian Kitten, 98
Sierra Juniper, 71
Sierra Penstemon, 44
Sizing, paper, 12
Skippack Antiques, 90
Soft edges, 54
Spatter, 38, 40-45
Spirit Shift, 67
Sponges, 19, 39
 exercises, 31
Spray bottle, 19
Sprays, 40, 84-87
Stamping, 39
Stencil brushes, 16
 exercises, 28
Still Life With Lamp, 104
Still Life With Scoop, 112
Stretching paper, 13
Sunlight on wood, 102
Supports, painting, 18

Surface, Carol, 50-53, 67
Surface, painting, 18
Szabo, Zoltan, 2

Tape, 19
 edges, creating with, 66-67
Techniques. See particular technique
Textile textures, 108-109
Thaw on Lizard Creek, 6
Todd and Lezlie's Wedding Flowers, 55
Tools. See Materials
Towels, paper
 exercises, 31
Travel brushes, 16
Trees
 bark, 71, 74-76
 distant, 71
 impressions, 77
 palette knives, creating with, 79
 seasonal, 72

Untitled, 46, 63

Varied edges, 54
Varied-width brush style, 47
Volcano, 48

Wagner, Judi, 8, 40
Water containers, 19
Water texture, 70
Webb, Frank, 48
Weeds, 80-81
Weights, paper, 12
Wet-into-wet techniques, 34
Wetness of paper, effect on texture, 56
Wet scraping, 62
White House Roses, 41
Wicker Coach, 114
Wicker textures, 114-117
Wiegardt, Eric, 43, 45, 55, 59, 63, 65
Wilson Peak, 87
Wind Weaver, 42
Winter Fog, 5
Wood texture, 70